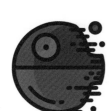
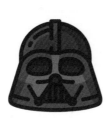
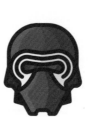
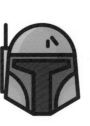

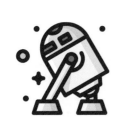

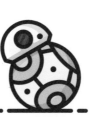

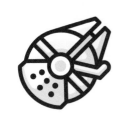
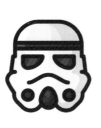
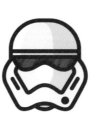
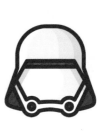

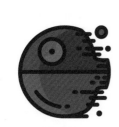
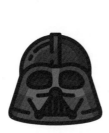
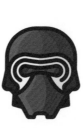
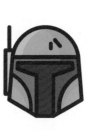

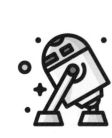
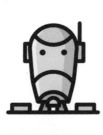
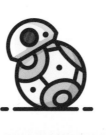

Star Wars Tribute
Copyright © 2017 Instituto Monsa de ediciones

Editor, concept, and project director
Anna Minguet

Project's selection
Anna Minguet
Design and layout
Eva Minguet
Cover design
Anna Minguet (Monsa Publications)
Introduction and text edition
Monsa Publications
Translation
Somos traductores

Cover image by Ron Domingue
Back cover image by Jose Pulido

INSTITUTO MONSA DE EDICIONES
Gravina 43 (08930)
Sant Adrià de Besòs
Barcelona (Spain)
Tlf. +34 93 381 00 50
www.monsa.com
monsa@monsa.com

Visit our official online store!
www.monsashop.com

Follow us!
Facebook: @monsashop
Instagram: @monsapublications

ISBN: 978-84-16500-55-0
D.L. B 17400-2017
Printed by Indice

By Anna Minguet

# STAR WARS
## Tribute

monsa

# Intro

The mere mention of the title Star Wars can evoke all kinds of feelings and memories in a person. The distant trilogy that thrilled everyone in the late 70's and early 80's, the highly criticized prequels from the early 2000's and now the new sequels, are just added fuel to make the work of George Lucas shine dazzlingly in our lives. But there's no mistaking it, Star Wars, now and forever, is part of our popular culture and our lives, whether you're a fan or simply someone who casually enjoys its universe, the clashes between jedi and sith or between rebels and imperialists have been a major attraction for us to go the cinema, but that experience was not enough to satisfy our interest. Numerous cartoon series, comics, books and video games have tried to capture the attention of all those who want more. Even so, we are still seeking to explore that faraway galaxy. There is a need to feel it and to make it one's own, crossing the limits of the media and managing to possess part of it, however small it may be.

This book is an illustrated tribute to the fictional universe created by George Lucas, in which you will find 40 portraits of its most outstanding characters, such as Luke Skywalker, Darth Vader, Leia Organa, Han Solo, Yoda, Chewbacca, R2-D2, C-3PO, Rey, Stormtrooper, Wilhuff Tarkin... and besides, 60 unpublished alternative posters!

Twenty-seven artists from around the world show us their most personal vision through one or more illustrations, expressing in a sentence what Star Wars means to them. In this way, many artists achieve their desire to share their life and work, along with that of Star Wars, returning the favour to what inspires them and in turn becoming part of the legend, for a long, long time.

"The Force will be with you. Always."
Obi-Wan Kenobi

La sola mención del título Star Wars puede evocar todo tipo de sensaciones y recuerdos en una persona, la ya lejana trilogía que impactó a todo el mundo a finales de los 70 y principios de los 80, las muy criticadas precuelas de principios del 2000 y actualmente las nuevas secuelas, sólo son leña al fuego que permiten hacer que la obra de George Lucas brille de manera deslumbrante en nuestras vidas. Pero no hay que equivocarse, Star Wars ahora y siempre, es parte de nuestra cultura popular y de nuestras vidas, seas fan o simplemente alguien que disfruta casualmente de su universo, los enfrentamientos entre jedis y sith o entre rebeldes e imperialistas, nos han hecho ir a las salas de cine con ilusión, pero esa experiencia no era suficiente para saciar nuestro interés. Numerosas series de animación, cómics, libros y videojuegos han intentado captar la atención de todo aquel que necesita más. Aun así seguimos buscando explorar esa galaxia muy, muy lejana como sea. Hay una necesidad de sentirla y hacerla propia, traspasando los límites del medio y consiguiendo poseer una parte por pequeña que sea.

Este libro es un tributo ilustrado al universo de ficción creado por George Lucas, en el que encontraréis 40 retratos de sus personajes más destacados como son Luke Skywalker, Darth Vader, Leia Organa, Han Solo, Yoda, Chewbacca, R2-D2, C-3PO, Rey, Stormtrooper, Wilhuff Tarkin... y 60 pósters alternativos inéditos!

Veintisiete artistas de todo el mundo nos muestran su visión más personal por medio de una o varias ilustraciones, expresando en una frase lo que significa para ellos Star Wars. Así es como muchos artistas superan el ansia de compartir de forma directa su vida y obra, junto a la de Star Wars, devolver el favor a aquello que les inspira y a su vez formar parte de la leyenda, por mucho, mucho tiempo.

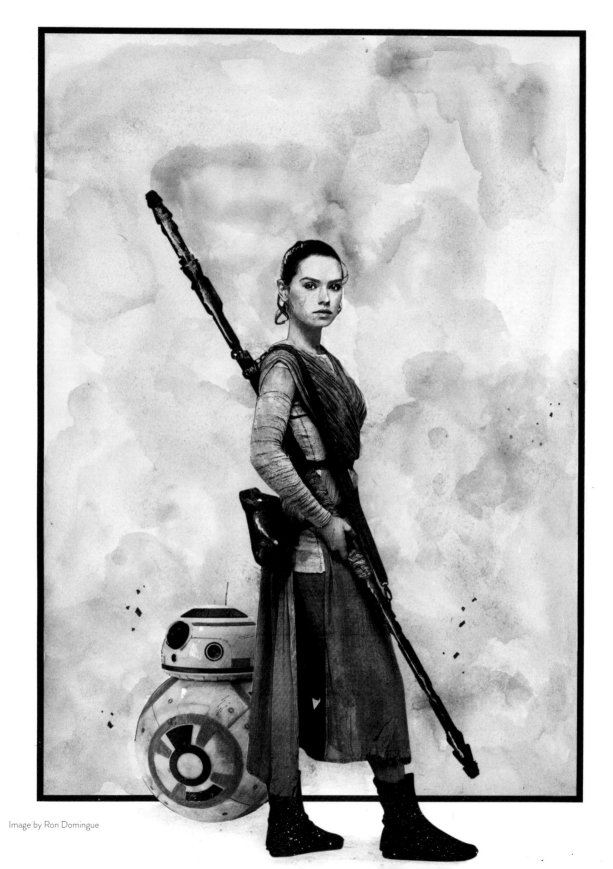

Image by Ron Domingue

# Index

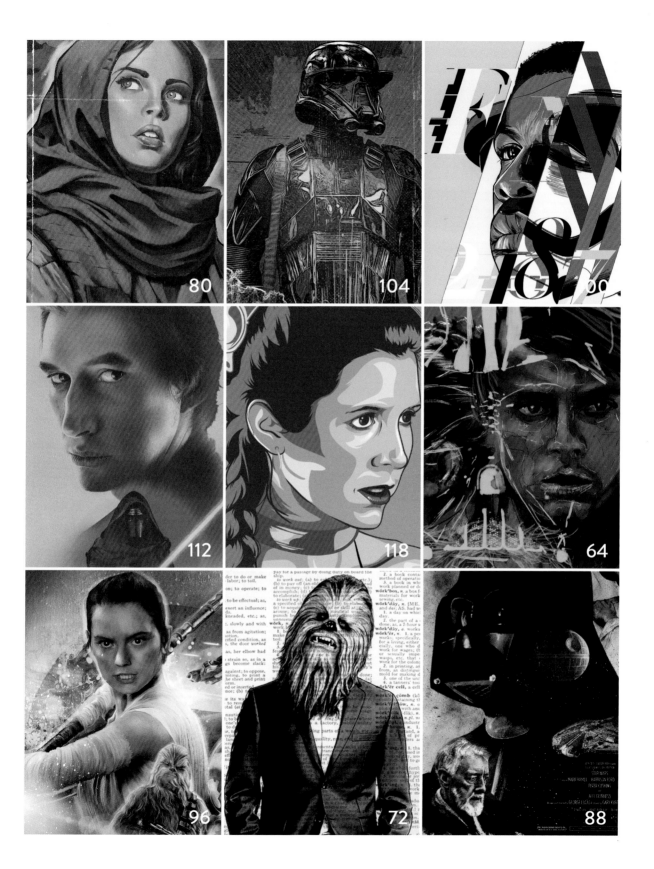

# Adán López Alemán

www.adanlopezart.com
Facebook: @adanluislopezalemanart
Etsy: ADAARTIllustrations

# "REMEMBER, CONCENTRATE ON THE MOMENT. FEEL, DON'T THINK. TRUST YOUR INSTINCTS. PAINT"

Adán Luis López Alemán (Spain, 1988) has been surrounded by the world of art since he was a child, as almost everyone in his family is or was an artist; His grandfather is a sculptor, his grandmother a portrait artist, his mother is a ceramist and his father was a muralist. In this environment "the child" was destined to have a special relationship with art. In his case, the fascination is directed towards painting and drawing. As Adán is a multidisciplinary artist, we can see different techniques such as watercolors, acrylics, oil paint, pastel and Chinese ink in his artwork. He has a mastered these techniques in an autodidactic form. He has a background in Industrial Design and is currently working as an industrial/interior designer in Valencia and you can clearly see how the art influences his work.

Adán Luis López Alemán (España, 1988) ha estado rodeado por el mundo del arte desde que era un niño. En su familia prácticamente todos son artistas. Tanto es así, que su abuelo es escultor, se abuela retratista, su madre ceramista y su padre muralista. Con este ambiente "el niño" también tenía que sentirse atraído por el arte. En su caso el interés por la pintura y el dibujo. Al ser un artista multidisciplinar, podemos observar en su obra diferentes técnicas tales como acuarelas, acrílicos, pintura al óleo, pasteles y tinta china. Ha desarrollado estas técnicas de manera autodidacta. Diseñador Industrial de forma profesional, aplica el arte a los distintos proyectos de diseño/interiorismo a los que se enfrente en su estudio de Valencia.

Darth Vader / Mixed watercolor and ink / Paper 210×297 mm  (right page)

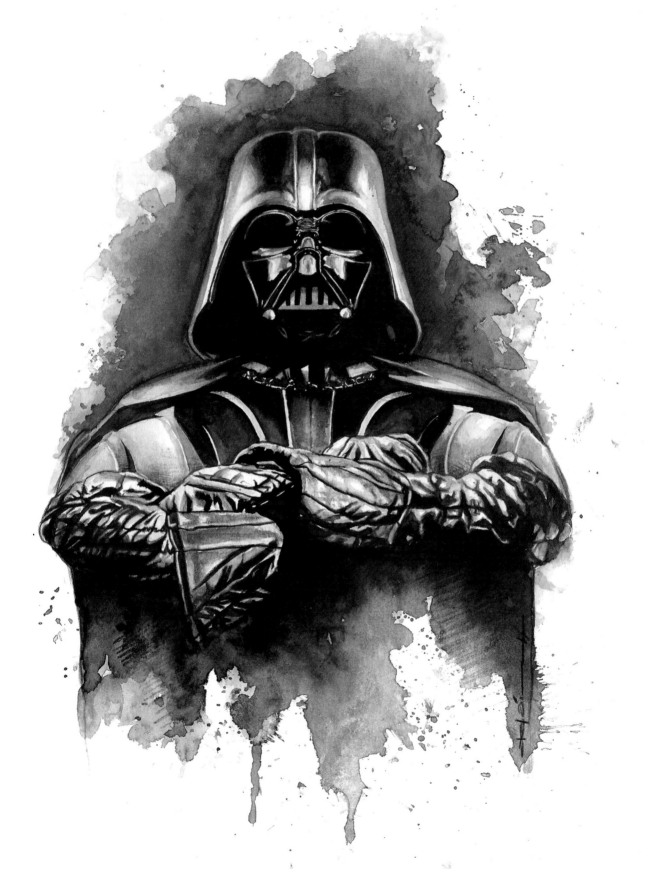

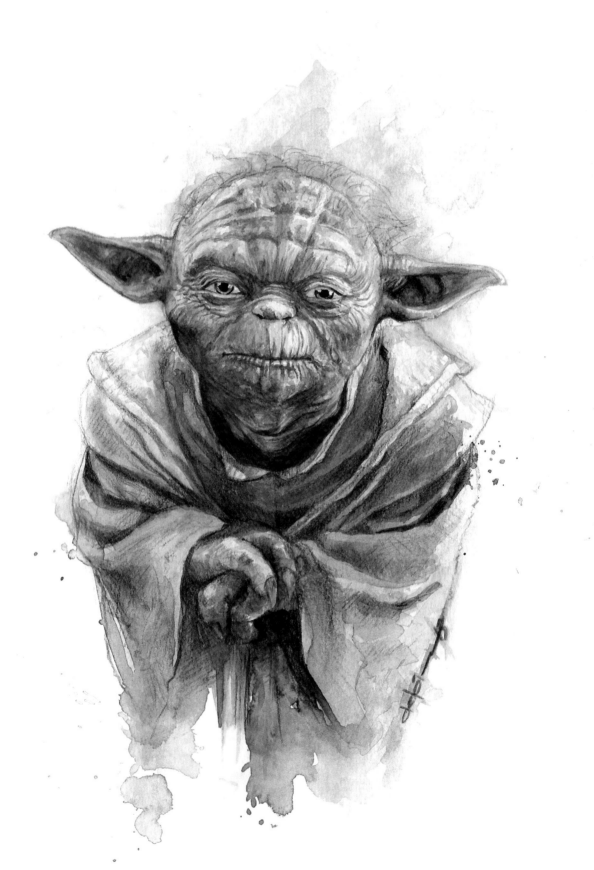

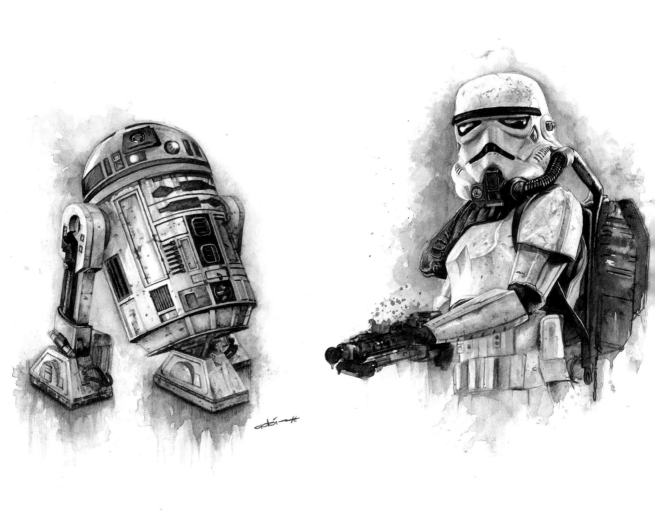

R2D2 / Mixed watercolor and ink / Paper 210×297 mm  (top left)
Stormtrooper / Mixed watercolor and ink / Paper 210×297 mm  (top right)
Yoda / Mixed watercolor and ink / Paper 210×297 mm  (left page)

# Enisaurus

www.enisaurus.com
Instagram: @eni_saurus

# "AS LONG AS THERE IS GOOD, THERE WILL BE EVIL"

Enisaurus is a Full-time Freelance Commercial Illustrator with a background in graphic design.

He loves drawing based on geometry, playing with intense colors and adding textures to his illustrations. Thinking in the right concept as the base of the meaning for each project is the main thing for him. A good thought idea builds a strong base to start the project and get the right intention and impact desire with it.

Enisaurus develops projects for helping companies, advertising agencies, magazines, books and private clients to communicate their services or products.

Working on side projects is really important for Enisaurus, he is always trying to combine real commissions with his love for experimenting and making new stuff every month. He claims that there is not another way to evolve as an illustrator, for growing beyond your limits, learning from your mistakes and enjoying the success to reach your goals.

His work is influenced by his love for movies, tv series, cartoons, books, comics, toys, video games and the pop culture from 80's until nowadays.

Enisaurus es un Ilustrador Freelance con un bagaje de diseñador gráfico adquirido tras sus estudios en dicha carrera.

Le encanta dibujar basándose en formas geométricas, jugando con intensos colores y añadiendo todo tipo de texturas a sus ilustraciones. Para él, pensar en el concepto adecuado como la base del significado de cada proyecto es la principal cosa a tener en cuenta. Una idea bien pensada construye una base sólida por la que empezar a trabajar y conseguir dar con la dirección correcta en cuanto a la intención e impacto que se desean.

Enisaurus desarrolla proyectos para ayudar a compañías, agencias de publicidad, revistas, libros y clientes privados a comunicar sus servicios o productos.

Trabajar en proyectos personales es muy importante para Enisaurus, él está siempre tratando de combinar encargos reales con su amor por experimentar y hacer cosas nuevas cada mes. De hecho tiene claro que no hay otro modo de evolucionar como ilustrador, para crecer más allá de tus límites, aprendiendo de tus errores y disfrutando de tu éxito.

Su trabajo está influenciado por su amor por el cine, las series, la animación, los juguetes, videojuegos y la cultura pop de los años 80 hasta hoy.

The Force Awakens (right page)

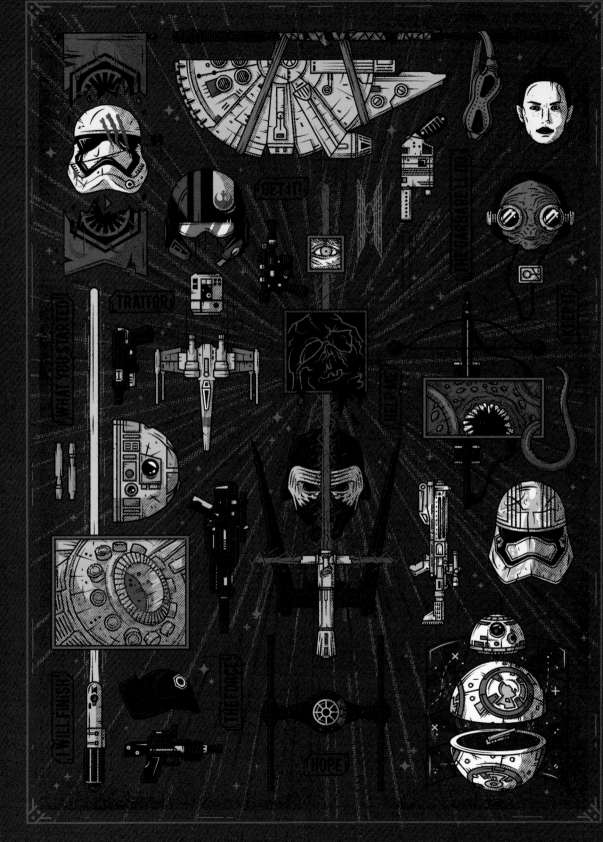

# Estevan Silveira

www.estevansilveira.com
Instagram: @estevan_silveira
Facebook: @estevansilveira

## "I FIND YOUR LACK OF FAITH DISTURBING"

Estevan Silveira is originally from Santa Maria, a small town located in southern Brazil. Nowadays he works as a freelancer based in São Paulo and works to large design, advertising and publishing companies.

He has always been interested in the power of the image as narrative construction and believes in the illustration as a mechanism to shift barriers of communication.

His work can be defined how a mix of traditional and modern that brings a classical approach due to composition and design and blends with a contemporary color palette and graphic treatment usually used in his drawings.

Inspired by movies, music, and comics. From sci-fi to horror his production finds in pop culture a unique point and a way to express itself that transcends the language barriers.

Estevan Silveira es de Santa María, una pequeña ciudad situada en el sur de Brasil. Actualmente trabaja como freelance en São Paulo y trabaja para grandes empresas de diseño, publicidad y editoriales.

Siempre ha estado interesado en el poder de la imagen como construcción narrativa y cree en la ilustración como una herramienta para transponer las barreras de comunicación.

Su trabajo se puede definir como una mezcla de lo clásico y lo moderno, crea un nuevo enfoque debido a la composición, el diseño, y a la mezcla de colores, dando un tratamiento gráfico que utiliza normalmente en sus ilustraciones.

Inspirado en películas, música y cómics. De la ciencia ficción al horror su trabajo encuentra en la cultura pop un lugar especial y una forma de expresarse que supera las barreras idiomáticas.

Abril Group / Super Interessante magazine / Art Direction: Flavio Pessoa / Illustrations: Estevan Silveira (right page)

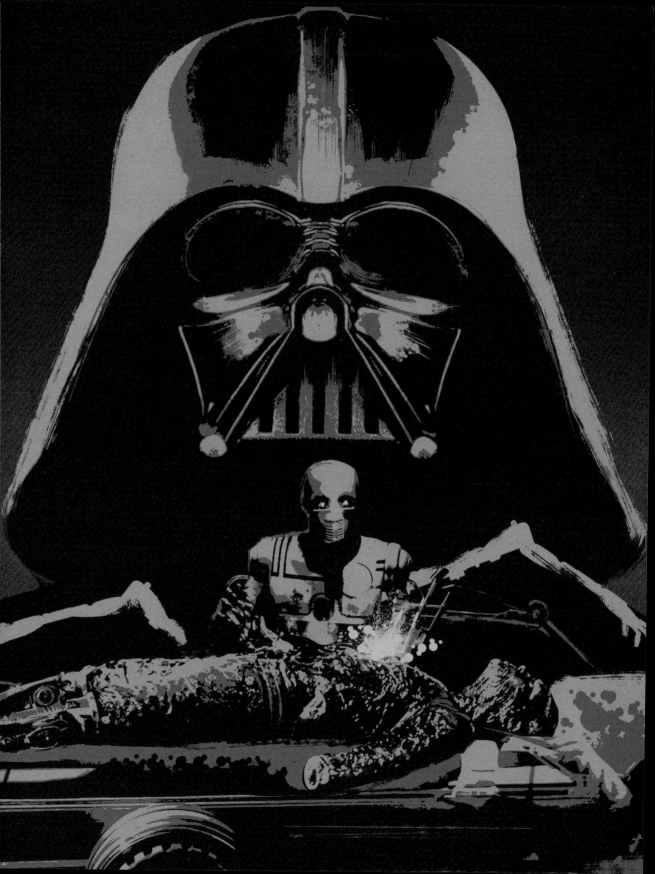

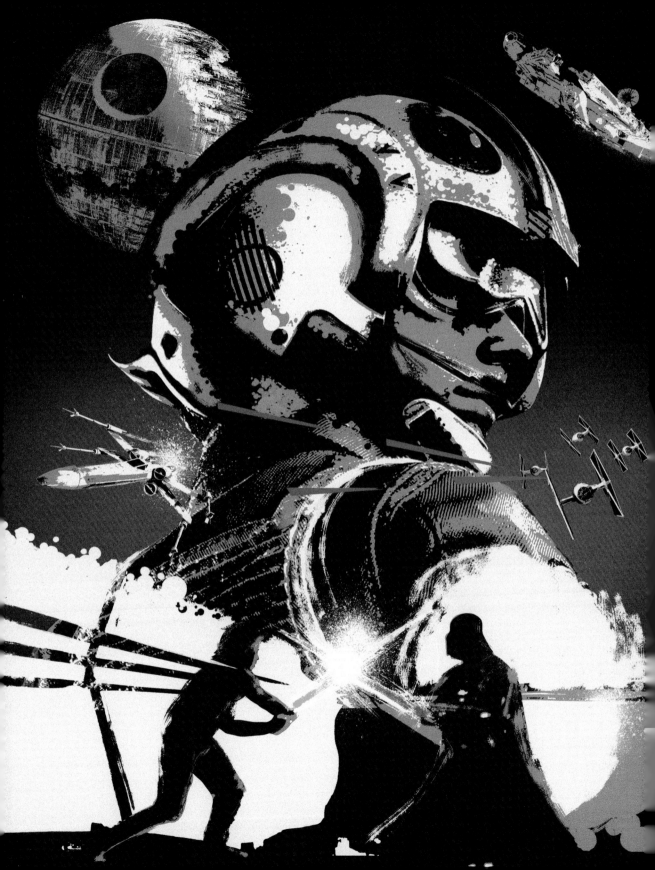

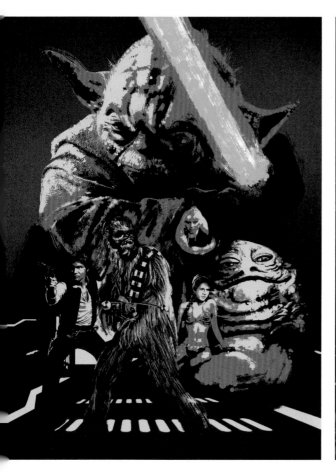
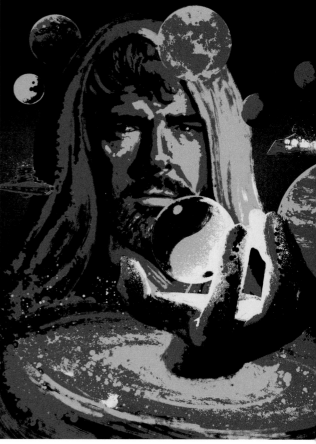

Abril Group / Super Interessante magazine
Art Direction: Flavio Pessoa / Illustrations: Estevan Silveira (both pages)

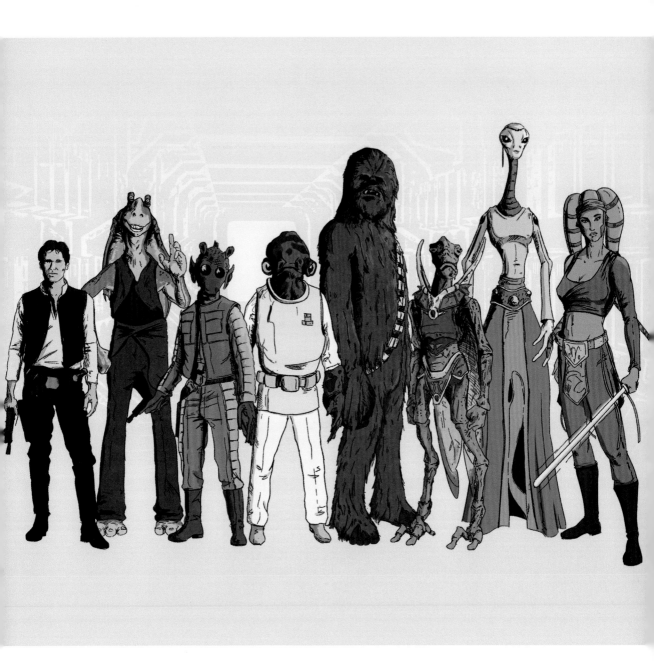

Abril Group / Super Interessante magazine
Art Direction: Flavio Pessoa / Illustrations: Estevan Silveira (both pages)

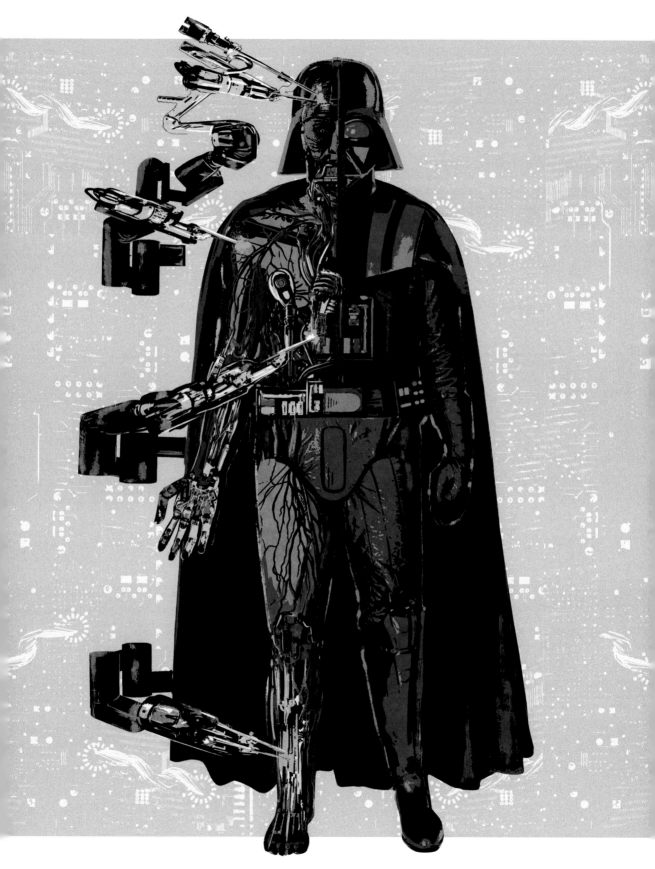

# Hamza Ansari

www.scanline-thoughts.tumblr.com
Instagram: @scanline_thoughts

## "STAR WARS IS THE ULTIMATE ESCAPIST FANTASY FOR ME. ONE OF MY FAVORITE FICTIONAL UNIVERSES"

Hamza Ansari is a self-taught graphic designer whose ultimate goal in life is to find stability and solace in what he loves doing. When he's not designing, he can be found either playing the latest video game on his computer, or re-watching the classics from his childhood. He to this day still owns the VHS cassettes of the original Star Wars trilogy!

Hamza Ansari es un diseñador gráfico autodidacta cuyo principal objetivo en la vida es encontrar estabilidad y consuelo en lo que más le gusta. Cuando no diseña, se le puede ver jugando al videojuego más nuevo en el ordenador o volviendo a ver los clásicos de su juventud. No en vano, a día de hoy aún conserva las cintas VHS de la trilogía original de Star Wars.

The First Lady of Space  (right page)

Mother

Rebel

Princess

Daughter

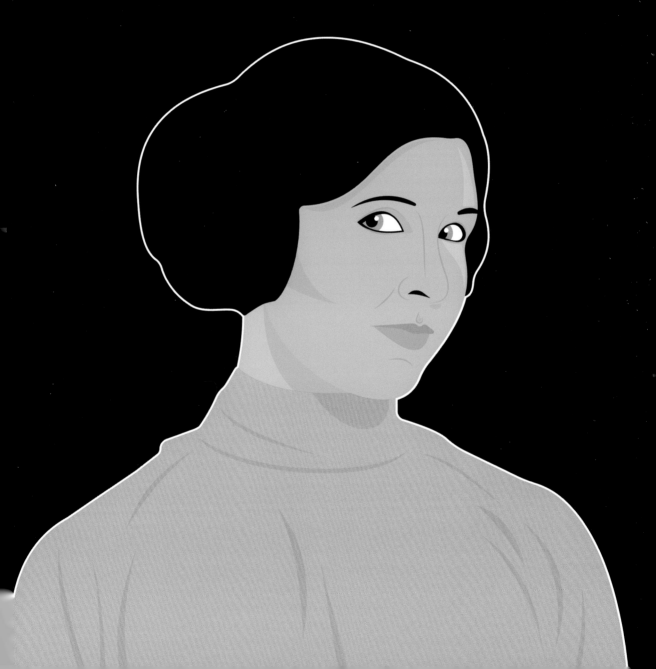

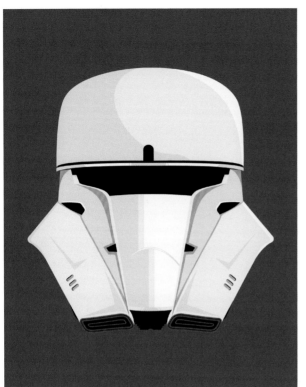

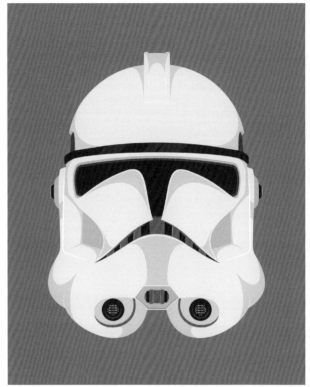

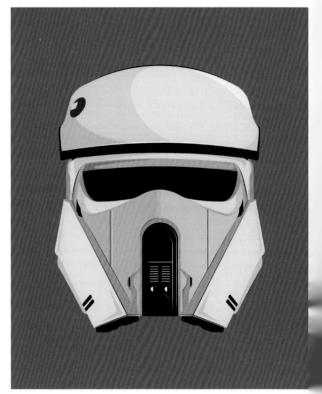

Tanktrooper (left)
Clonetrooper (right)
Shoretrooper (bottom)
Adorable Droid BB-8 (right page)

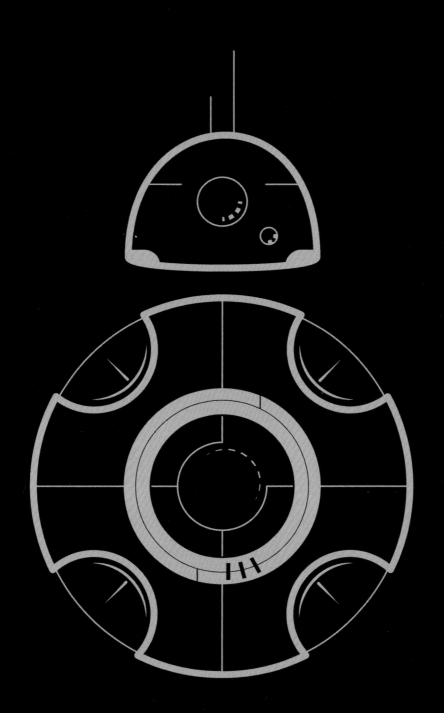

# Jérémy Pailler

www.jeremypailler.com
Instagram:jeremy_pailler
Facebook: @PaillerJeremy
Twitter: @jeremy_pailler

## "AN INSPIRING MYTHOLOGY. AN IMMERSIVE JOURNEY"

Jérémy Pailler is a French illustrator, animator and Fine Art PhD. Whether he works on short animated films, picture books for children or movie posters, his atmospheric ink on paper depict a dark and poetic world conducted by strong narrative arcs. Jérémy's work has been shown in galleries in France, Iceland, England, Portugal and the United States, as well as in film festivals around the world. *Dragon Dancer*, his first picture book, was published by Lantana Publishing and he won awards in Venezuela and the United States for his short animation *Gerdas Vej*, inspired by The Snow Queen. He took part in two artist residencies in Iceland and Thailand. He writes papers about the creative dynamics mobilized during the creation of animated features and teaches animation in France. Jérémy is a member of the Poster Posse, who commissioned this artwork for the release of *Rogue One*.

Jérémy Pailler es un ilustrador francés, animador y doctor en Bellas Artes. Ya sea cuando trabaja en documentales de animación, libros de ilustraciones para niños o carteles cinematográficos, su tinta atmosférica sobre el papel refleja un mundo oscuro y poético dirigido por sólidos arcos narrativos. El trabajo de Jérémy ha sido expuesto en galerías de Francia, Islandia, Inglaterra, Portugal y Estados Unidos, así como en festivales cinematográficos de todo el mundo. Su primer libro de ilustraciones, *Dragon Dancer*, publicado por Ediciones Lantana, fue galardonado con diversos premios en Venezuela y Estados Unidos por su breve animación *Gerdas Vej*, inspirada en la Reina de la Nieve. Asimismo, participó en dos residencias para artistas en Islandia y Tailandia. Jérémy escribe artículos sobre la dinámica creativa que se moviliza durante la creación de elementos animados, además de dar clases de animación en Francia. También es miembro de Poster Posse, que le encargó esta obra para el estreno de *Rogue One*.

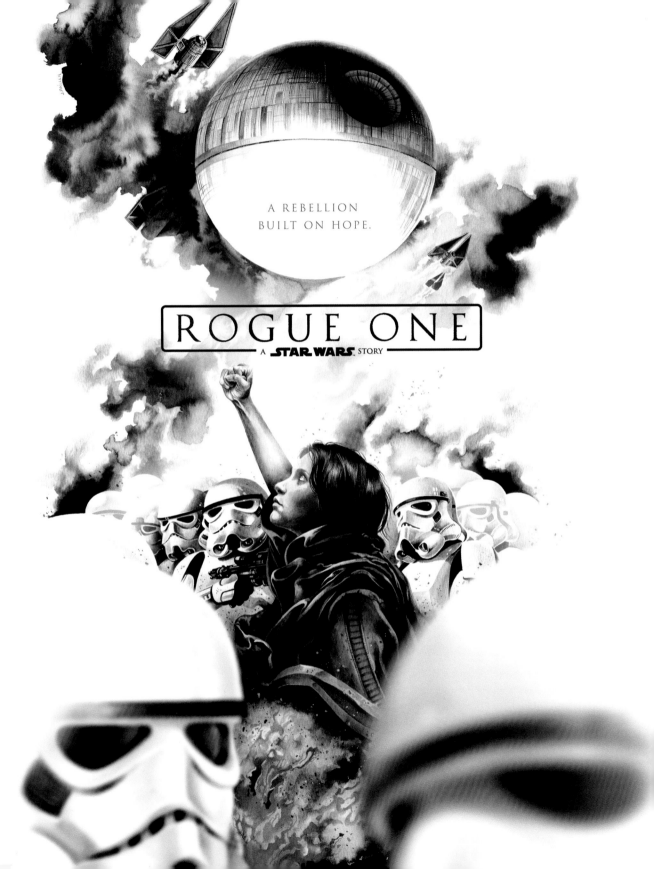

A REBELLION
BUILT ON HOPE.

ROGUE ONE

A STAR WARS STORY

# Joe Stone

www.joe-stone.co.uk
Instagram: @joestone/
Twitter: @joe_stone

## "STAR WARS HAS GIVEN US AN ENTIRE GALAXY OF UNLIMITED POSSIBILITIES"

Joe Stone is a British graphic designer and illustrator. Raised on a steady diet of comics, video games and movies, pop culture has had a huge impact on his work, and he now spends most of his free time drawing dumb things and posting them on the internet. He lives and works in London, and likes it there very much.

"Star Wars was one of the first science-fiction movies I saw as a child, and it opened my eyes to this world of possibilities and wonder and creativity that I didn't know existed until that point. If I hadn't seen it then I genuinely wouldn't be the person that I am today, doing the work that I do."

Joe Stone es un ilustrador y diseñador gráfico británico. Inmerso desde su infancia en el mundo del cómic, el cine y los videojuegos, la cultura pop ha tenido una gran influencia en su trabajo. Actualmente, dedica la mayor parte de su tiempo libre a dibujar banalidades y subirlas a Internet. Joe vive y trabaja en Londres, donde es plenamente feliz.

"Star Wars fue una de las primeras películas de ciencia ficción que vi de niño, y lo cierto es que me abrió los ojos a un mundo de posibilidades, maravilla y creación que hasta entonces no sabía que existía. Si no la hubiera visto entonces, estoy seguro de que ahora no sería quien soy ni me dedicaría a lo que me dedico".

Queuebacca (right page)

QUEUEBACCA

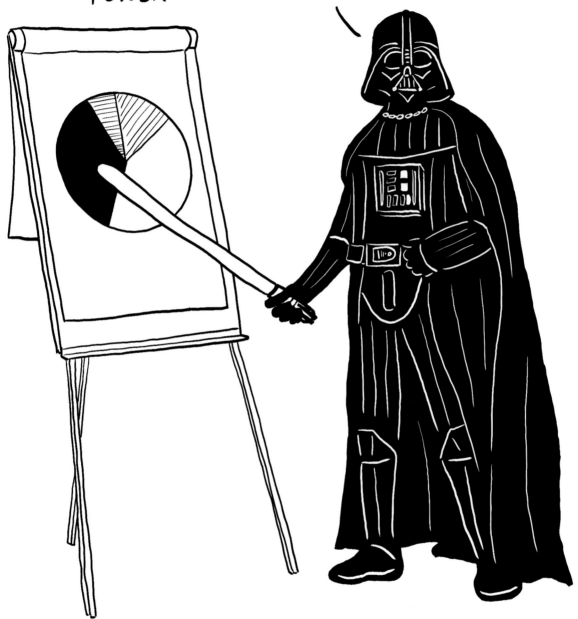

GRAPH VADER

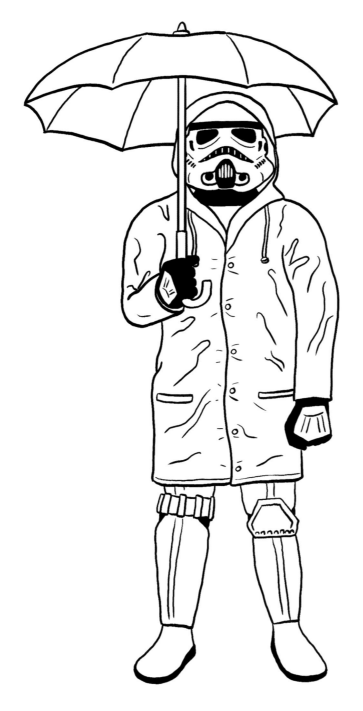

S T O R M T R O O P E R

# Jose Pulido

www.misnopalesart.etsy.com
Instagram: @misnopales
Facebook: @misnopaleart

# "STARS WARS TO ME IS A WINDOW INTO MY CHILDHOOD, FULL OF IMAGINATION AND WONDER"

I am an artist from southern California, where I have lived all of my life. I have been drawing for as long as I can remember and I haven't stopped yet. My artwork is inspired by Mexican art and culture, as well as American pop-culture. My calaveras originally grew from my inspiration from Jose Guadalupe Posada's work. I really enjoyed his work and particularly the many skeletons that he created. Some of my calaveras are a modern take on the calaveras he created about people and characters from his time. The difference is that our time is filled with tons of popular culture from video games, movies, cartoons, and other things that weren't around back in his time.

I currently reside in Downey, California, creating Art and living with my wife and daughter. I hold an Illustration degree from California State University Fullerton.

Soy un artista del sur de California, donde he pasado toda mi vida. Dibujo desde que tengo uso de razón, y a día de hoy aún sigo haciéndolo. Mis obras se inspiran en el arte y la cultura mexicanos, así como en la cultura pop de Estados Unidos. Para crear mis calaveras, me inspiré en las obras de José Guadalupe Posada, por cuyo trabajo siento una profunda admiración, en especial por sus numerosos esqueletos. Algunas de mis calaveras son una versión moderna de las calaveras que creó sobre las personas y personajes de su época, con la diferencia de que nuestra era está repleta de cultura popular gracias a los videojuegos, películas, dibujos animados y otros elementos que no existían en la suya.

Actualmente vivo en Downey, California, donde resido y creo arte con mi mujer y mi hija. Soy licenciado en ilustración por la California State University Fullerton.

Droid Calaveras / 2 color Gocco screenprint - 2010 (right page)

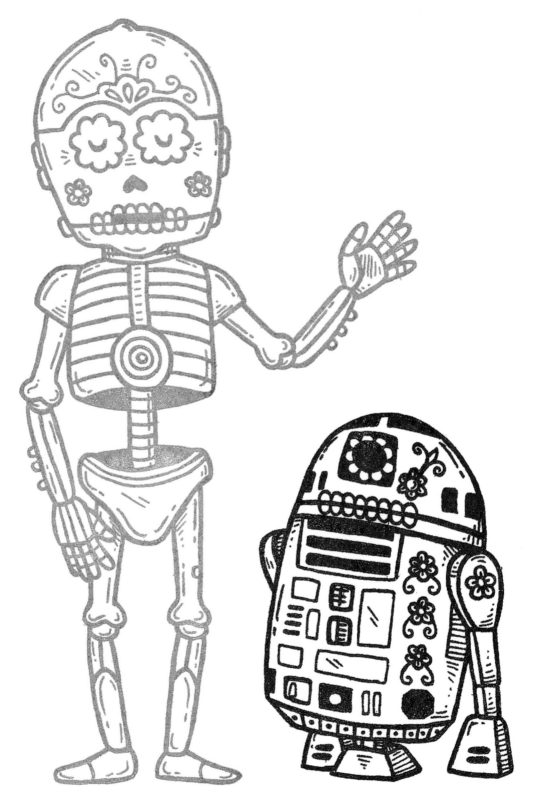

19/200

José Pulido

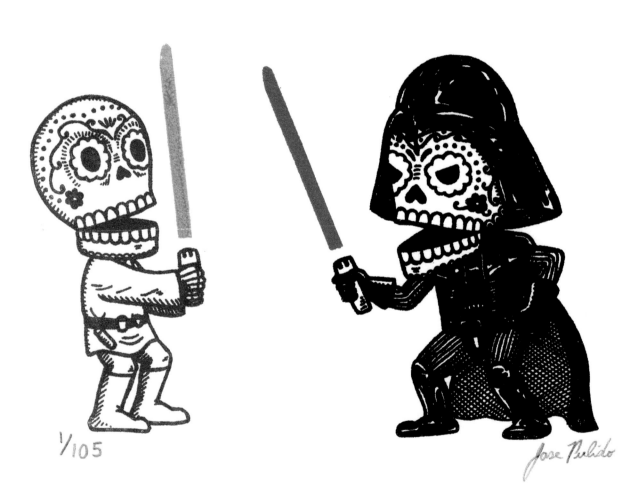

<sup>1</sup>/105

Jose Pulido

Star Wars Calaveras / 3 color Gocco screenprint - 2009

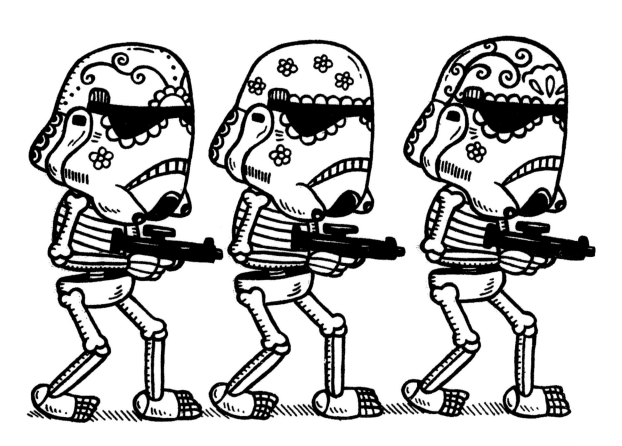

105

*Jose Pulido*

Storm Trooper Calaveras / 1 color Gocco screenprint - 2009

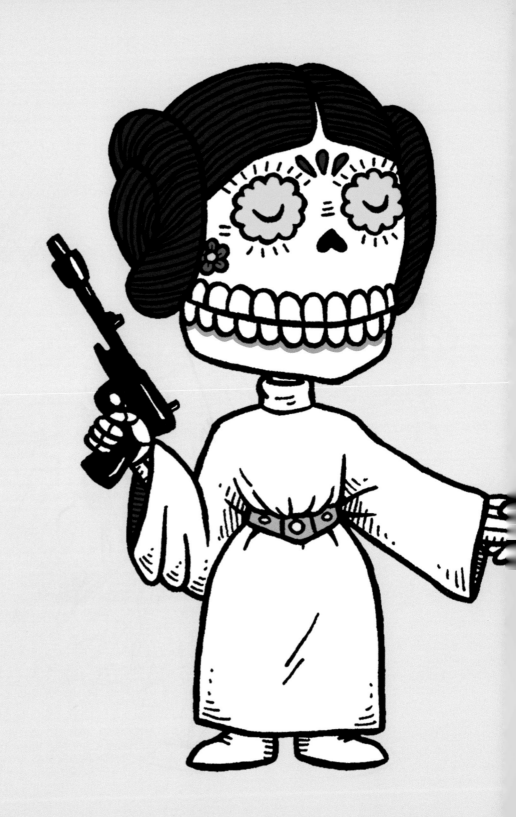

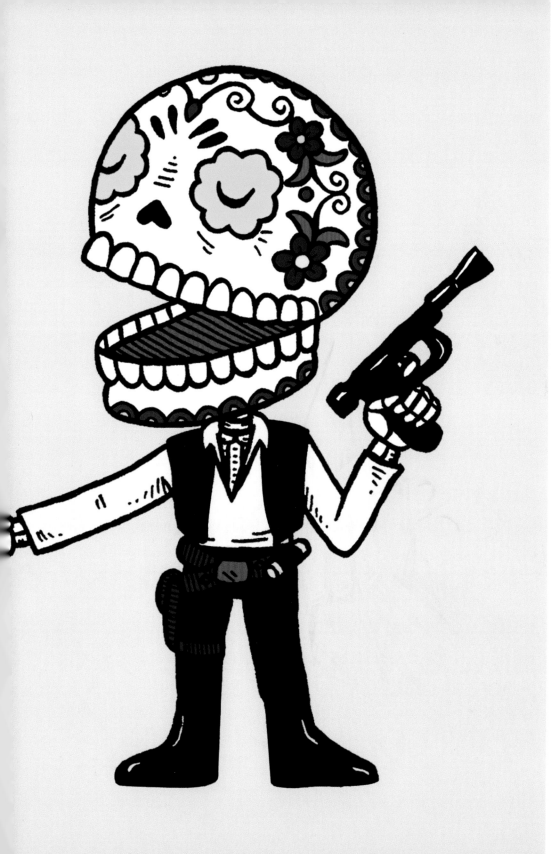

# Justas Galaburda

www.iconutopia.com
www.pinterest.com/JustasDesign
Instagram: @iconutopia/
Twitter: @IconUtopia
Facebook: @iconutopia
Dribbble: @jucha

## "AN ICONIC MOVIE THAT OPENS FROM NEW PERSPECTIVES EACH TIME YOU WATCH IT"

When he is not rewatching Star Wars for the 100th time, Justas is creating icons and illustrations -- the two other passions of his. He's also the founder of the high-end blog about iconography -- Iconutopia.com, where he teaches everyone from rookies to the industry talents how to make a steady income and build a career as an icon designer. Justas' secret weapon is sincerity and devotion -- he shares his own experiences and only reveals the techniques that he's tried. Add some (lots of!) creativity and eye-catching designs, and you will get what he's all about. In fact, his desire to help and spread creativity has resulted into the icon design guide that Justas wrote and shared for free! His spare time (if he has any) he spends working on side projects and freebies for the design community.

Cuando no está viendo Star Wars por enésima vez, Justas está creando ilustraciones e iconos, sus otras dos pasiones. También es fundador del prestigioso blog sobre iconografía Iconutopia.com, en el que enseña a todo el mundo, desde novatos hasta talentos del sector, cómo lograr un flujo constante de ingresos y labrarse una carrera como diseñador de iconos. El arma secreta de Justas es la sinceridad y la dedicación (comparte sus propias experiencias, revelando solo las técnicas que ha probado). Si a ello le sumamos una pizca (o varias) de creatividad y diseños llamativos, entenderemos perfectamente su figura artística. De hecho, su deseo de difundir la creatividad y de contribuir a ella se ha traducido en la creación de una guía de diseño de iconos que Justas ha compartido de forma gratuita. En su tiempo libre (si es que le queda), se dedica a trabajar en proyectos paralelos y de cortesía para la comunidad de diseñadores.

Storm Trooper (right page)

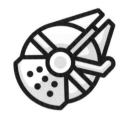
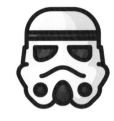
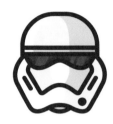
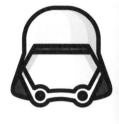

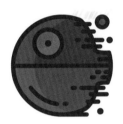
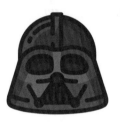
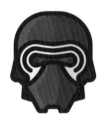
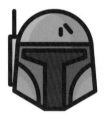

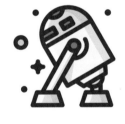
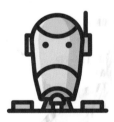
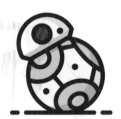

All icons
R2D2 (right page top)
BB8 (right page bottom)

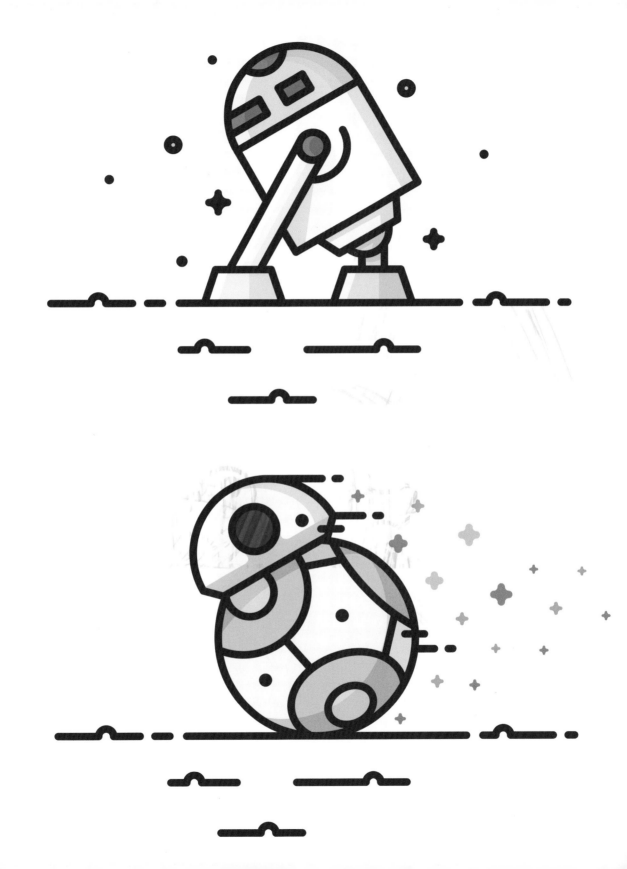

# Kenny Sin

www.kennysinart.tumblr.com
Instagram: @kennysin8

## "MAY THE FORCE BE WITH YOU"

I am a freelance illustrator, working and living in Hong Kong. I design characters, illustrate, storyboard and motion graphics. More than 10 years of experience in this field.

Soy un ilustrador freelance que vive y trabaja en Hong Kong. Diseño personajes, ilustraciones, guiones y gráficos animados, un ámbito en el que cuento con más de 10 años de experiencia.

Darkside (right page)

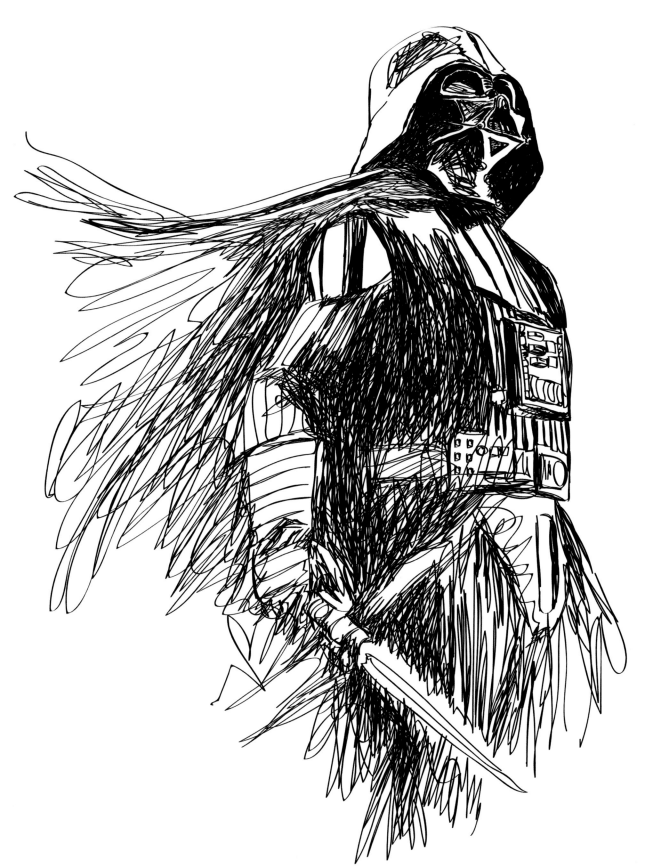

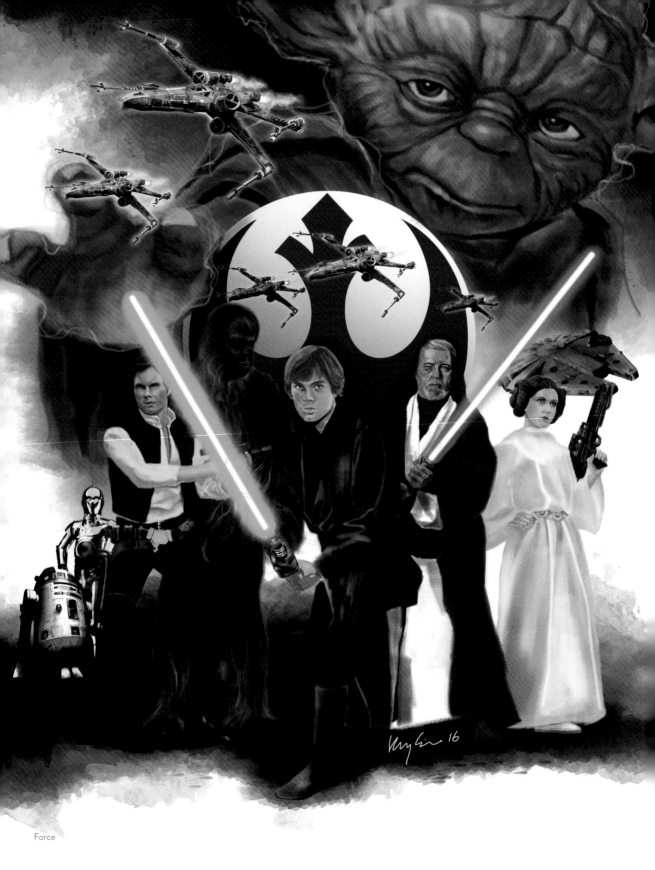

Force

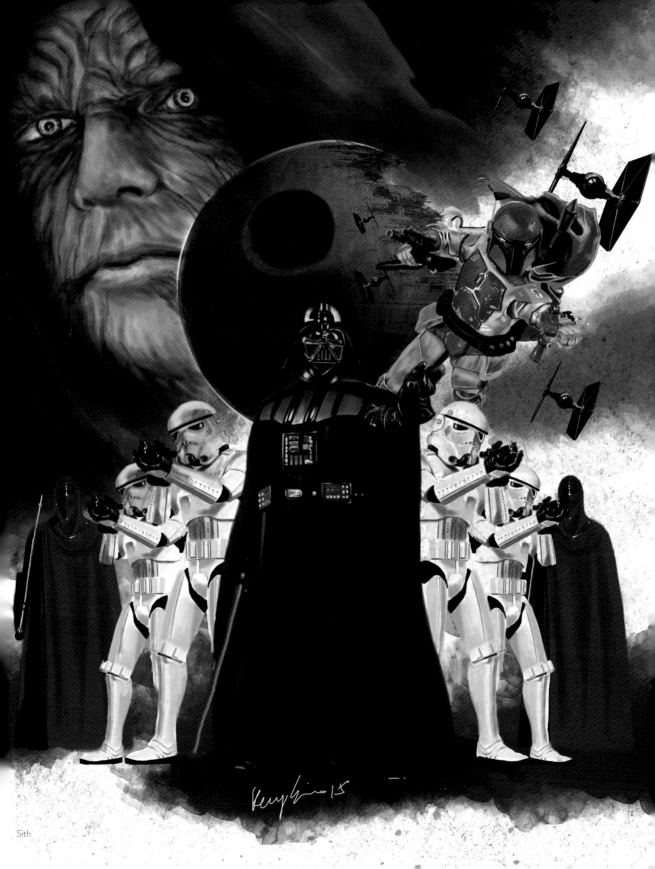

Sith

# Kreg Franco

www.kregfranco.com
www.behance.net/kregfranco
Instagram: @kregfranco
Facebook Page: @kregfrancoartcollection

## "THE MEANING OF THE FORCE IS VERY REAL TO ME"

New York City-based artist, Kreg Franco, seeks to capture the essence of people and characters through highly detailed and rendered portraits. He's continually enriching his knowledge through observations; illustrating portraits in diverse ways according to the subject. Born and raised in Queens, Kreg has attended the High School of Art & Design and has pursued degrees in Illustration at the Fashion Institute of Technology. He's currently exhibiting his artwork across the country. Kreg has been featured in several galleries; from New York's Comic Con & Chelsea, to Miami's Art Basel, all the way to California. His goal is to have viewers recognize the soul in his portraits, as each face has its own story to tell.

El artista neoyorquino Kreg Franco busca capturar la esencia de las personas y personajes mediante retratos con un elevado nivel de detalle y representación. Kreg enriquece continuamente sus conocimientos mediante la observación, dibujando retratos de diversas maneras según el sujeto del que se trate. Nacido y criado en Queens, Kreg estudió en el Instituto de Arte y Diseño y ha completado sus estudios en Ilustración en el Fashion Institute of Technology, exponiendo sus obras de arte en diversas galerías de todo Estados Unidos, desde la Comic Con & Chelsea de Nueva York a la Art Basel de Miami, pasando por galerías de California. Su objetivo es que los espectadores reconozcan el alma de sus retratos, puesto que cada rostro tiene una historia que contar.

Starts INK Portraits (right page)

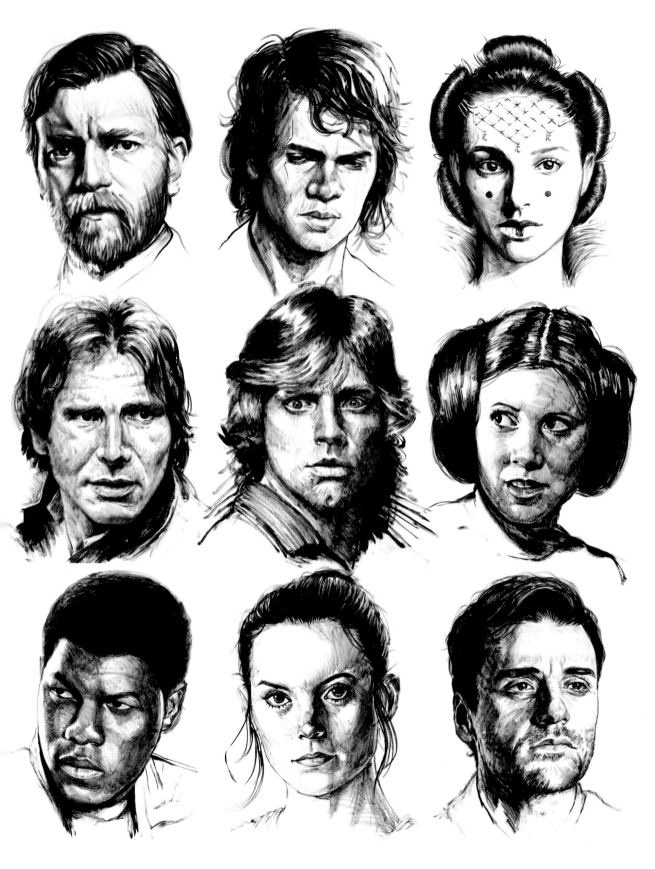

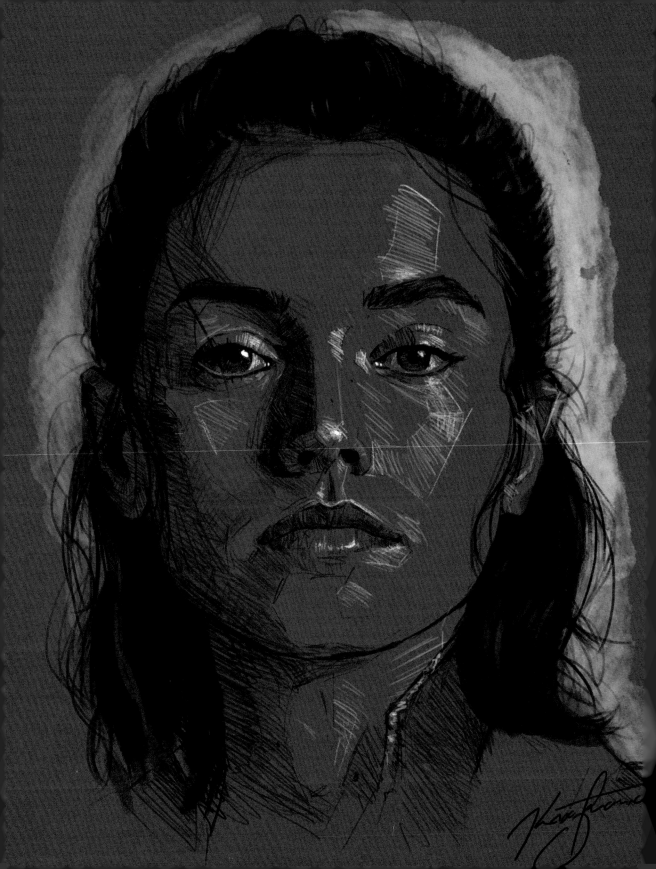

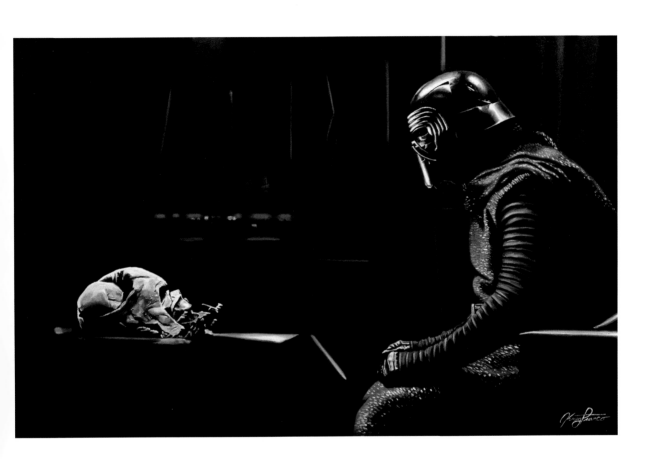

Kylo Ren's Confession - Oil painting
Rey (left page)

# Matthew Esparza

www.wonderbros.com
Instagram: @wonderbros

## "THE IDEA. THE MYSTERY. THE LASERS!"

Matthew is a designer/illustrator based out of Texas. When asked about his inspirations, Matt recalls, "The three most important films of my childhood were Back to the Future, The Thing and The Empire Strikes Back." After seeing these films, he learned three solid life lessons:
Rock music can save your life, Your friends could be aliens And, of course, Become a space ninja.

Matthew es un diseñador e ilustrador de Texas. Cuando le preguntan qué es lo que le inspira, Matt recuerda que "las tres películas más importantes de mi infancia fueron *Regreso al Futuro, La cosa* y *El imperio contraataca*", de las cuales extrajo tres importantes lecciones de vida:
"el rock puede salvarte la vida"; "tus amigos pueden ser aliens"; y por supuesto, "conviértete en un ninja espacial".

Star Wars (right page)

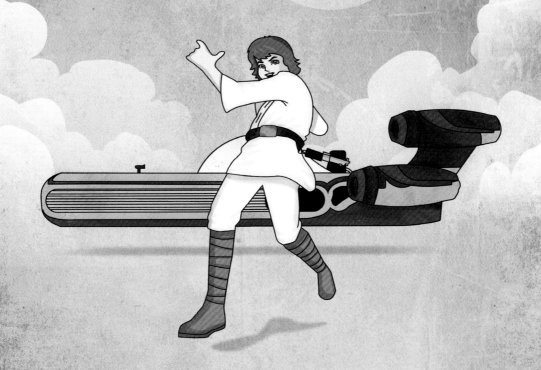

A long time ago in a galaxy far, far away....

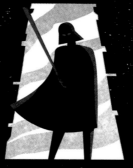

STAR WARS

THE

EMPIRE

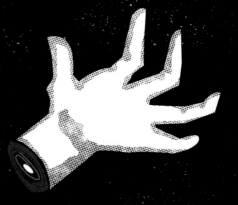

STRIKES BACK

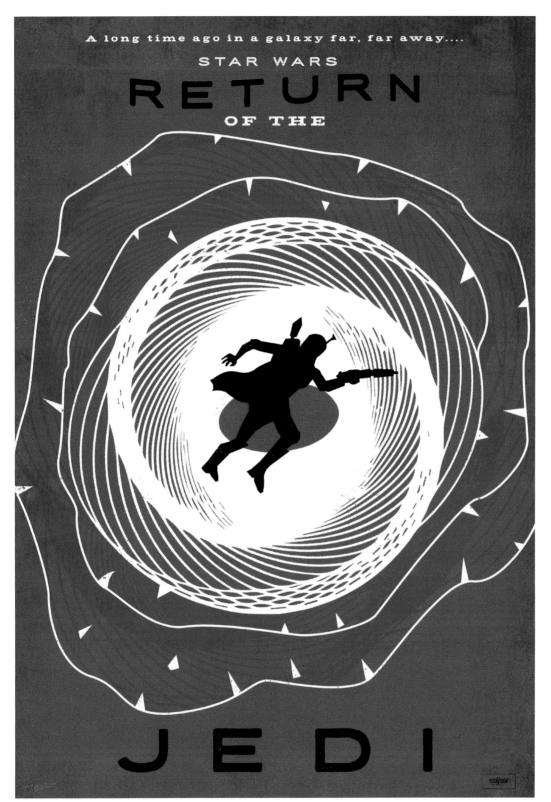

Jedi

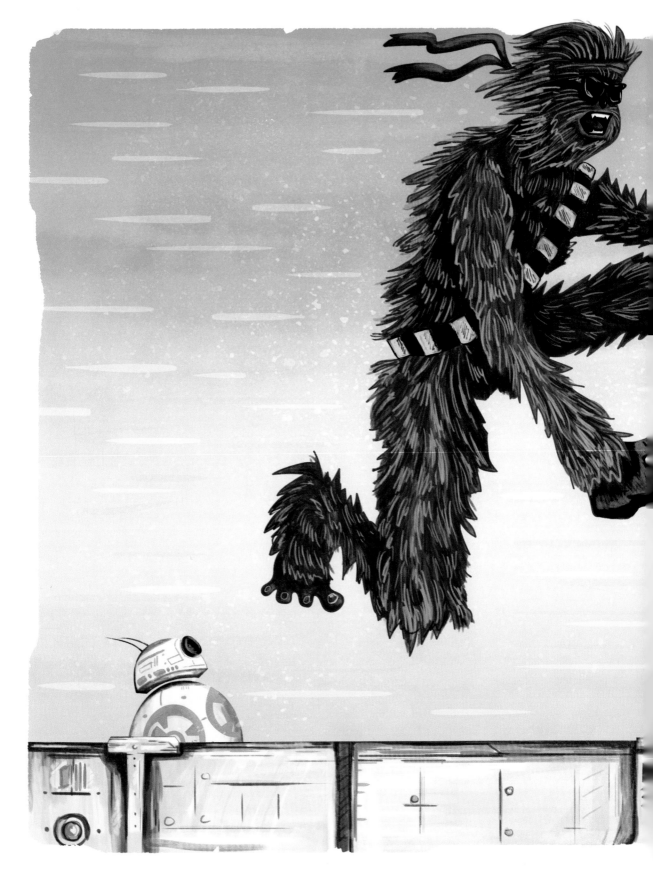

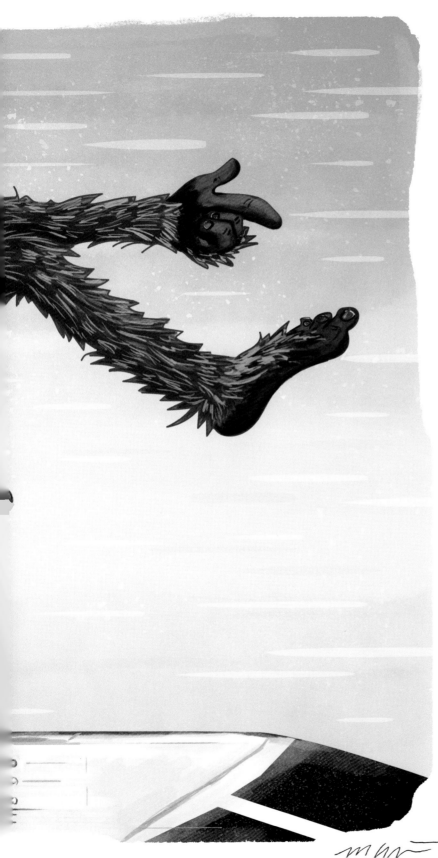

Teen Wookie

# Media Graffiti Studio

www.MediaGraffitiStudio.com
Instagram: @mediagraffitistudio

"STAR WARS INSPIRES ME TO CONSTANTLY INFUSE THAT CHILD LIKE ENTHUSIASM I FELT THE FIRST TIME I SAW THE MOVIES INTO
ALL OF MY ARTWORK!"

California based artist and illustrator Rick Martin created Media Graffiti Studio as an outlet where his interests in Pop Art, Graffiti, Rock-N-Roll, Photography, Comic Books, and Movies are filtered through a prismatic funnel of bombastic zen to produce his "Media Graffiti" style art. His goal is to create artwork that will make a BOLD statement when added to any room. Ricks unique style of mixing fine art, graffiti and graphic novel illustrations together has created a growing fan base worldwide. To see more of the work being released by Rick Martin visit his website at www.MediaGraffitiStudio.com.

El artista e ilustrador californiano Rick Martin creó Media Graffiti Studio como una vía de escape en la que su interés por el arte pop, los grafitis, el rock and roll, la fotografía, los cómics y las películas se filtran a través de un embudo prismático cargado de un ampuloso zen para dar lugar a su estilo artístico "Media Graffiti". Su objetivo es crear obras que añadan un toque de atrevimiento a la sala en la que se expongan. El estilo único de Rick, que combina bellas artes, grafitis e ilustraciones de novelas gráficas, ha dado pie al nacimiento de un fenómeno fan por todo el mundo. Para más información sobre las obras que tiene previsto publicar, consultar la web www.MediaGraffitiStudio.com.

Cloud City  (right page)

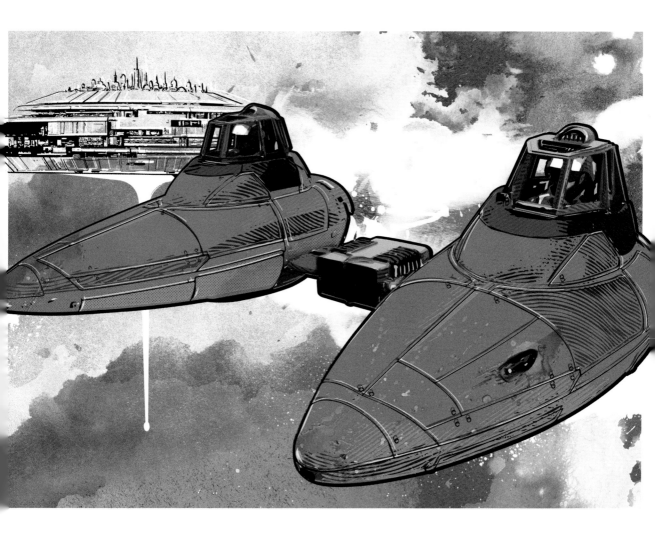

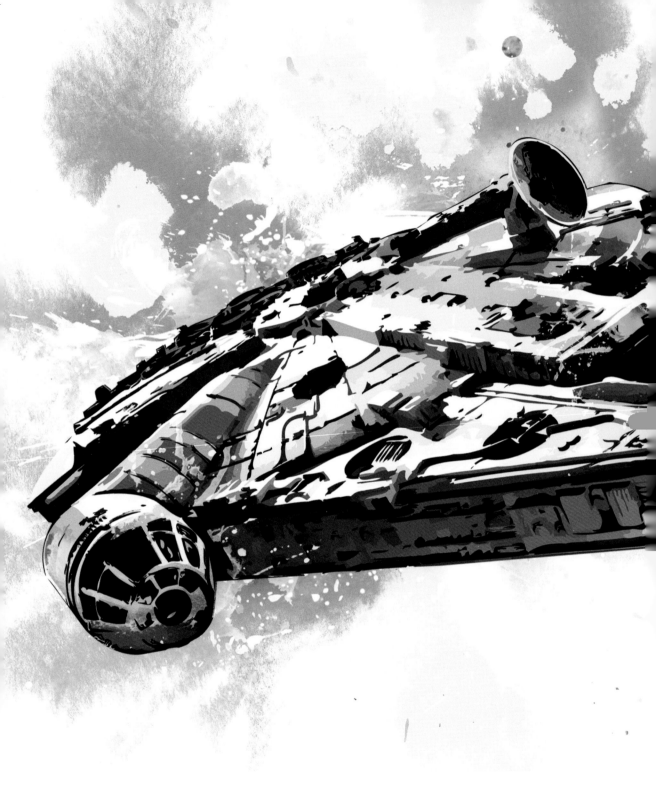

The Falcon

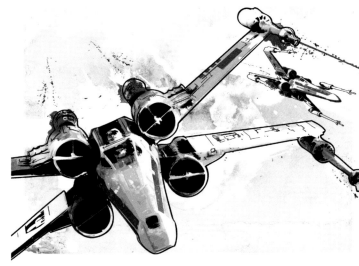

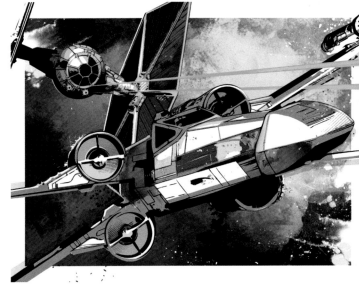

The XWings (top)
Space Battle (bottom)

# IdleBadger

www.etsy.com/uk/shop/IdleBadger
Instagram: @idlebadger

"STAR WARS IS SOMETHING THE BRINGS THE BEST OUT OF PEOPLE. BE IT CREATIVITY IN ART, COSTUMES, REPLICAS, FAN FILMS, MUSICAL SCORES, EVERYONE CAN RELATE TO SOMETHING THAT THEY LOVE ABOUT THE STAR WARS UNIVERSE"

IdleBadger is an English team of two artists based in Bristol, UK. Made up of Sam Turner and Tom Swain, the two of them collaborate to design, produce, print and sell various types of minimalist poster designs based on the Star Wars universe. With a shared love of everything Star Wars, they focused on memorable moments from each planet in the Star Wars movies and transformed them into minimalist designs. They also produce prints designed from other movies and video games as well as Star Wars.

IdleBadger es un equipo inglés compuesto por Sam Turner y Tom Swain, dos artistas de Bristol (Reino Unido) que colaboran para diseñar, producir, imprimir y vender varios tipos de carteles minimalistas basados en el universo de *Star Wars*. Aunque ambos sienten una profunda admiración por todo lo que rodea a la saga, han decidido centrarse en los momentos memorables de cada planeta que aparecen en las películas y transformarlos en diseños minimalistas. También producen diseños impresos de otras películas y videojuegos, así como de *Star Wars*.

Endor (right page)

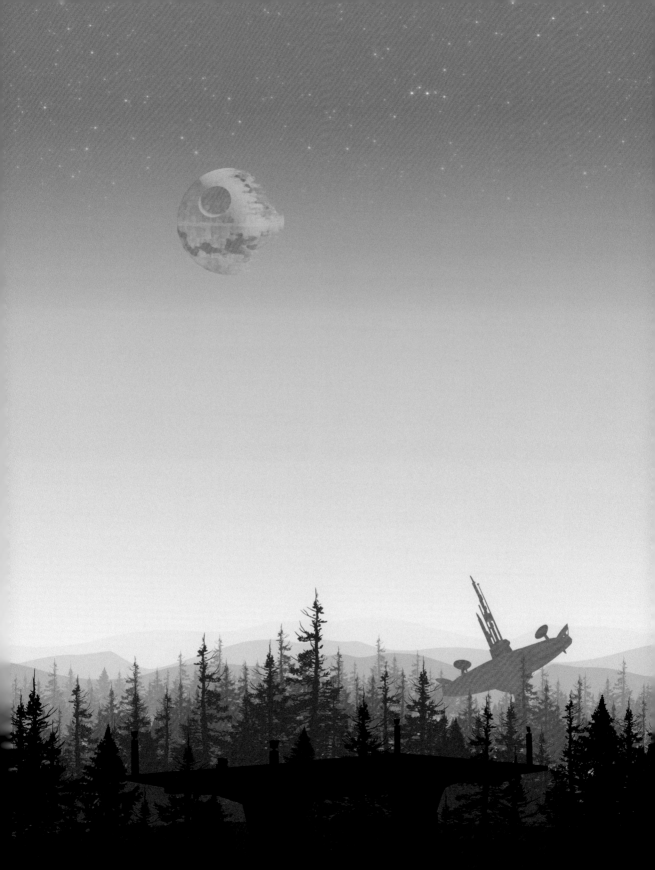

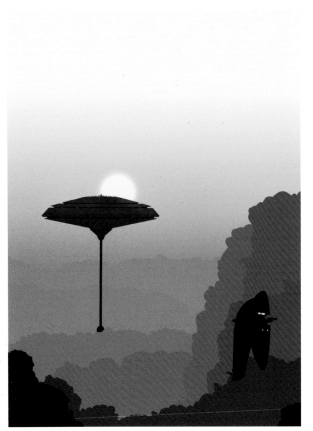 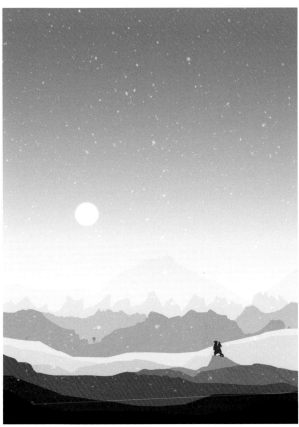

Bespin (left)
Hoth (right)
Tatooine (right page)

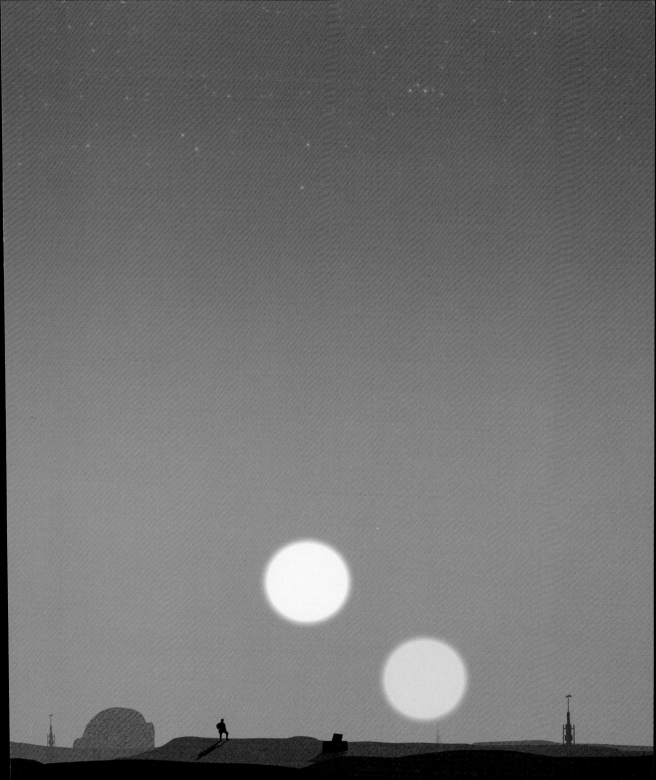

# Rafal Rola

www.rafalrola.pl
Instagram: @rolarafal/
Facebook: @RafalRola02

# "THE AESTHETIC OF THE STAR WARS SERIES IS THRILLING!"

Philosophy graduate, artist based in Poland. His art consists mainly of portraits full of organic textures, light and darkness; being present in diverse elements of composition.

Artista polaco licenciado en Filosofía. Su arte consiste fundamentalmente en retratos repletos de texturas orgánicas, luz y oscuridad que se combinan en diversos elementos de la composición.

Rogue One (right page)

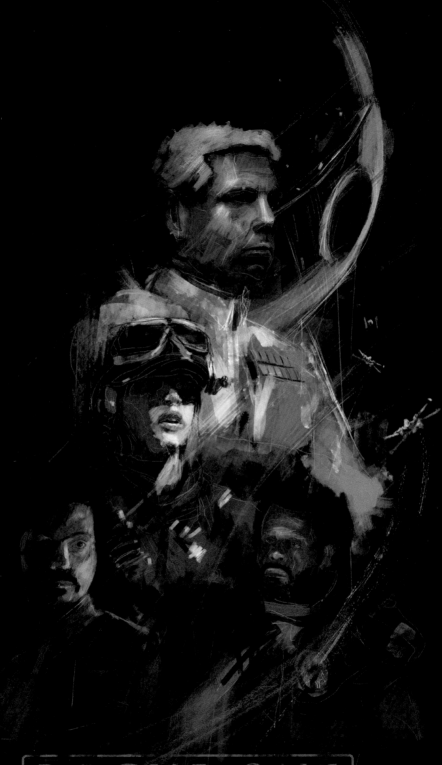

ROGUE ONE

A STAR WARS STORY

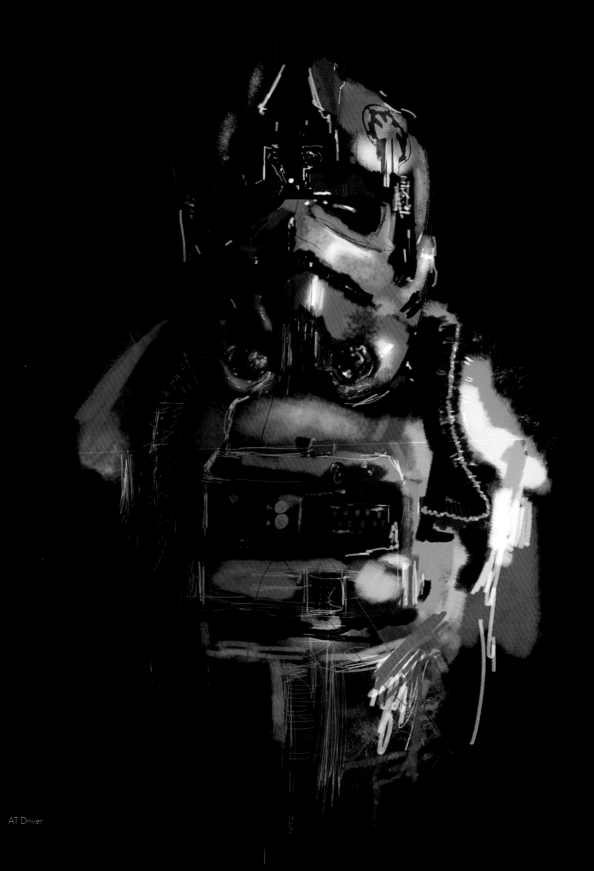

AT Driver

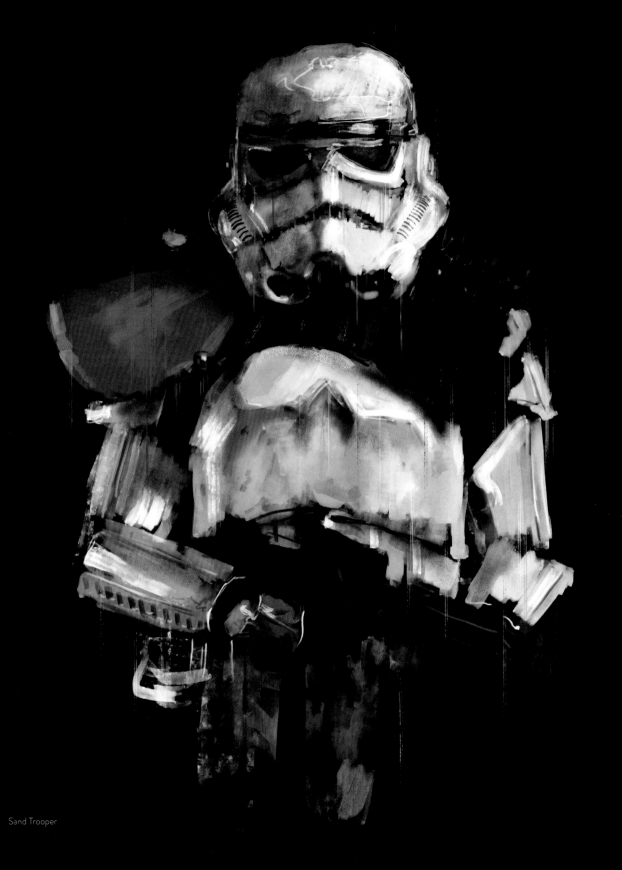

Sand Trooper

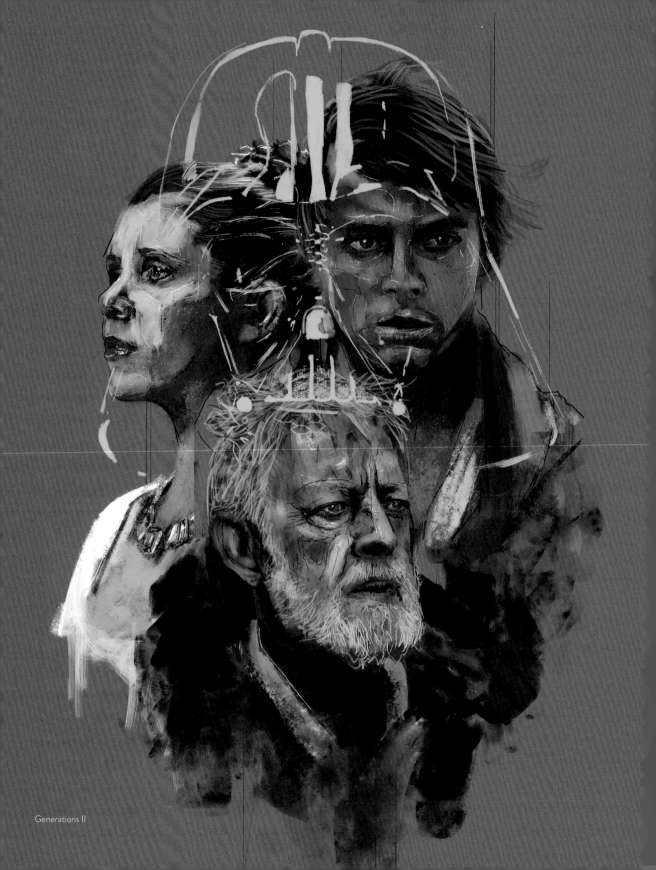

Generations II

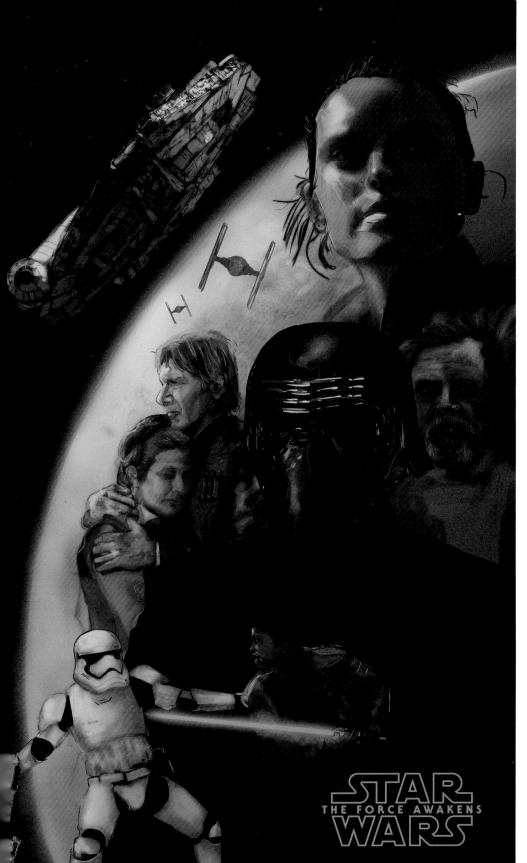

Star Wars
The Force Awakens Rola

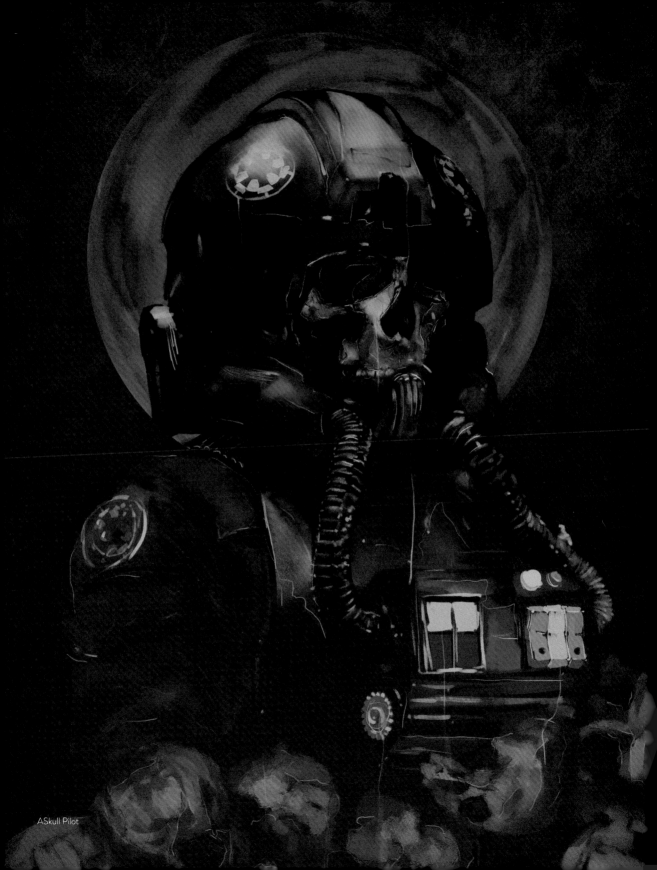

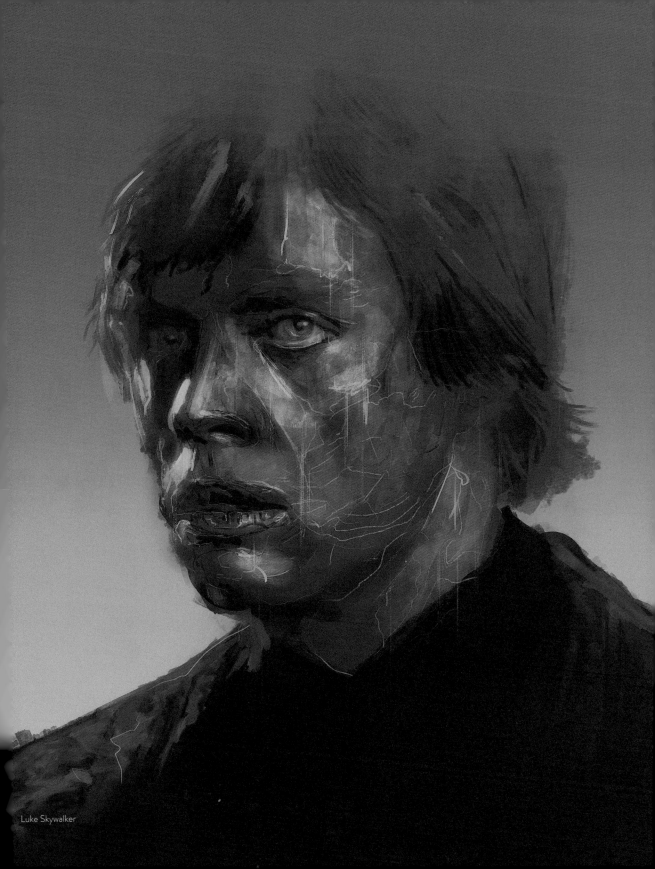
Luke Skywalker

# MEOWconcept

www.etsy.com/shop/MEOWconcept

# "MAY THE SUIT BE WITH YOU"

"MEOWconcept" is a Hong Kong based art studio established in 2010. Tony Chow and Arthur Hengco-founded MEOWconcept, the studio specializes in graphic design,painting and illustration. The common link between Tony and Arthur is that both of them have a combination of skills. Tony has a working knowledge of leading the creative process from concept to completion. Arthur has a master's degree in painting and graphics, but he's also been doing digital visual arts as a serious hobby for many years. They believe their creations have a unique charm and they hope in visiting their Etsy-site all the people will find something to enjoy.

"MEOWconcept" es un estudio de arte de Hong Kong creado en 2010, fundado por Tony Chow y Arthur Hengco, y especializado en diseño gráfico, pintura e ilustraciones. Tony y Arthur comparten un vínculo común: ambos gozan de habilidades complementarias. Tony sabe cómo dirigir profesionalmente el proceso de creación, desde su diseño hasta su finalización, mientras que Arthur, que tiene un máster en pintura y grafismo, también se dedica al arte visual digital desde hace muchos años, tomándose su hobby verdaderamente en serio. Ambos consideran que sus creaciones desprenden un encanto único, y esperan que todo el mundo que visite su web Etsy encuentre algo que le guste.

Image courtesy by MEOWconcept (right page)

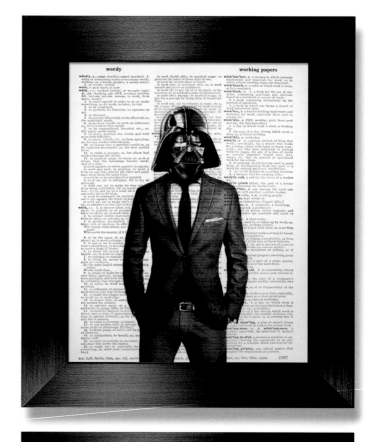

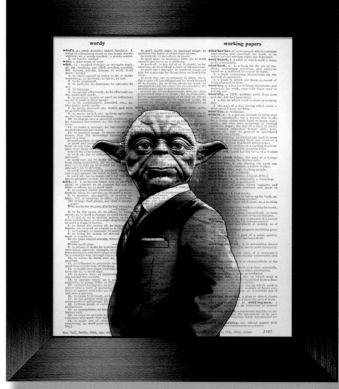

Images courtesy by MEOWconcept (top and bottom)

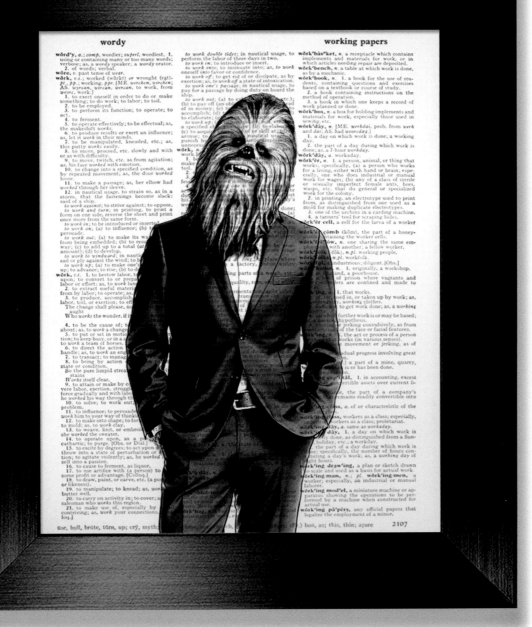

# Guy Stauber

www.shogungraphicsystems.co.uk
Instagram: @guystauber
Facebook: @guystauber
Twitter: @SHOGUNSYSTEMS

# "I WAS ALWAYS INSPIRED BY HOW 'LIVED IN' THAT UNIVERSE FELT... IT WAS DENTED & SCRATCHED & RUSTY, LIKE STUFF HAD BEEN HAPPENING THERE FOR THOUSANDS OF YEARS BEFORE WE DISCOVERED IT"

Guy set up Shogun Graphic Systems™ in 2001, providing a bespoke digital illustration service to a wide range of international clients.

Raised on a staple diet of Marvel comics, cult TV shows & of course Star Wars, Guy has long been fascinated by popular culture & how it continues to influence our lives.

He has never been quite the same since that Star Destroyer first cruised over our heads in 1977...

Guy is currently represented by Richard Solomon Artist Reps based in Manhattan, & has recently exhibited work at Hero Complex Gallery in L.A & Comic Con in New York.

Clients include Sports Illustrated, DC, Marvel, Lucasfilm, Disney & Fox TV amongst others.

Guy currently lives & works in Southampton, UK.

Guy creó Shogun Graphic Systems™ en 2001, ofreciendo un servicio de ilustraciones a medida a una amplia gama de clientes de diversos países.

Inmerso desde su infancia en el universo de los cómics Marvel, programas televisivos de culto, y por supuesto Star Wars, Guy siente verdadera fascinación por la cultura popular y su influencia a día de hoy en nuestras vidas. Guy no ha vuelto a ser el mismo desde que el Destructor Estelar sobrevolara nuestras cabezas por primera vez en 1977.

Actualmente, Guy está representado por la agencia Richard Solomon Artist Rep, con sede en Manhattan, y hace poco expuso sus obras en la Hero Complex Gallery de Los Ángeles y en la Comic Con de Nueva York. Entre sus clientes podemos destacar a Sports Illustrated, DC, Marvel, Lucasfilm, Disney o la Fox. Guy vive y trabaja en Southampton, Reino Unido.

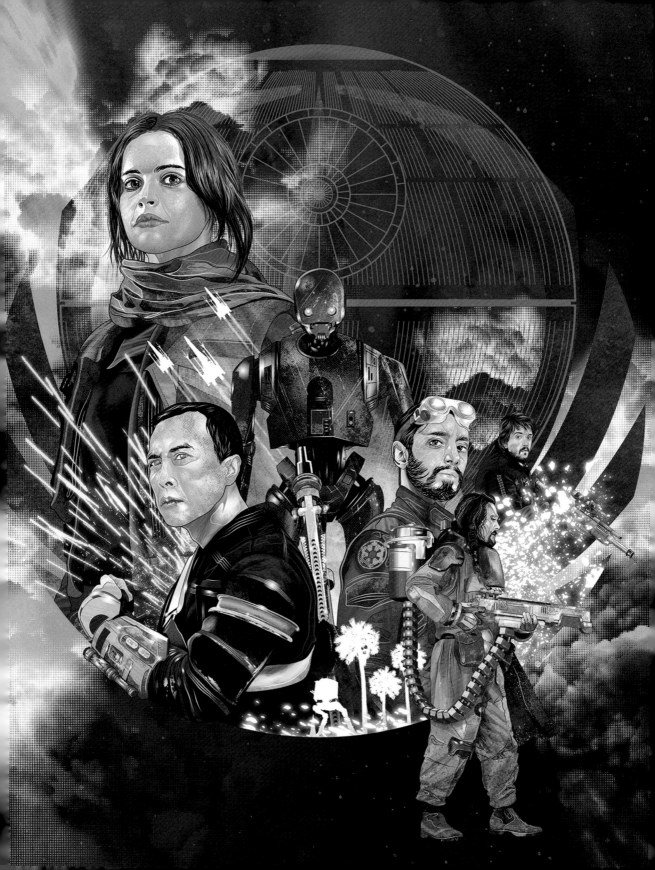

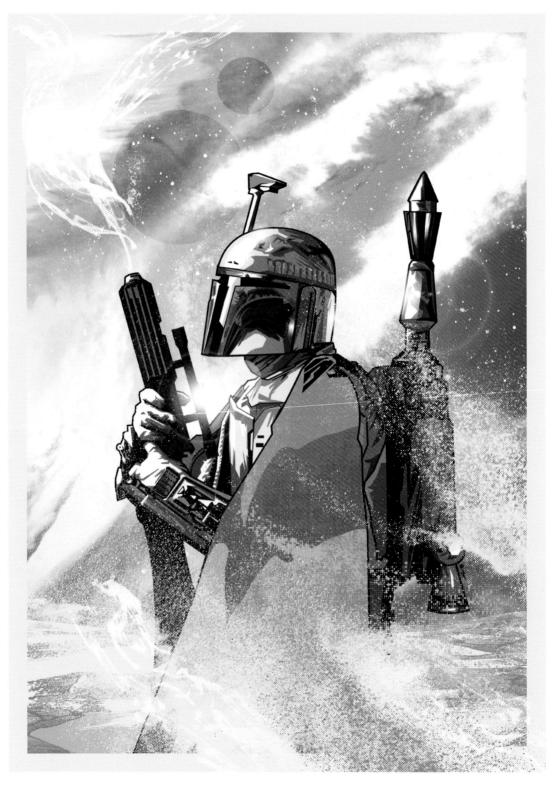

Boba Fett Ralph McQuarrie

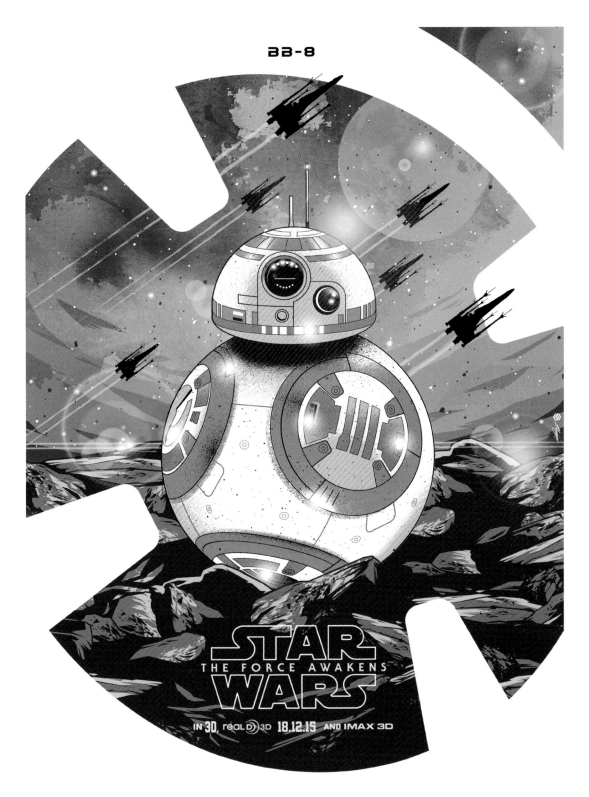

# Aleksei Kot

Instagram: @alieksei_kot
Facebook: @alieksei.kot
Twitter: @aliekseikot

## "THE AESTHETIC OF THE STAR WARS SERIES IS THRILLING!"

Alexey Kot is an artist and graphic designer based in Belarus working worldwide as a freelancer.

He works primarily on movie posters and board games design in a vintage style. The most inspiring artists are J.C. Leyendecker and Tamara de Lempicka.

His passion for vintage art began after the pilot project "Retro Movie Posters of Modern Movies" that was executed digitally.

The idea to make a poster for "Rogue One" was born after realizing that it's a prequel for original trilogy, that could be filmed in 40's – 50's, and it's a great opportunirty to combine things he loves: Star Wars and vintage art.

His favorite part of Star Wars universe is "Knights of The Old Republic" because this game tooks all the best of SW and greatly improved it.

Alexey Kot es un artista y diseñador gráfico de Bielorrusia que trabaja como freelance por todo el mundo.

Se dedica principalmente a diseñar carteles de películas y juegos de mesa, con un estilo vintage. Los artistas que más le han inspirado son J.C. Leyendecker y Tamara de Lempicka.

Su pasión por el arte vintage surgió tras el proyecto piloto digital "Retro Movie Posters of Modern Movies".

La idea de diseñar un cartel para *Rogue One* se le ocurrió tras darse cuenta de que se trataba de una precuela de la trilogía original que podría haber sido filmada en los 40 o los 50, y que le daba la oportunidad de combinar sus dos pasiones: *Star Wars* y el arte *vintage*.

Lo que más le gusta del universo de *Star Wars* es el juego "Los caballeros de la Antigua República", que tomó todo lo mejor de la saga y lo mejoró de forma considerable.

Grand Moff Tarkin (right page)

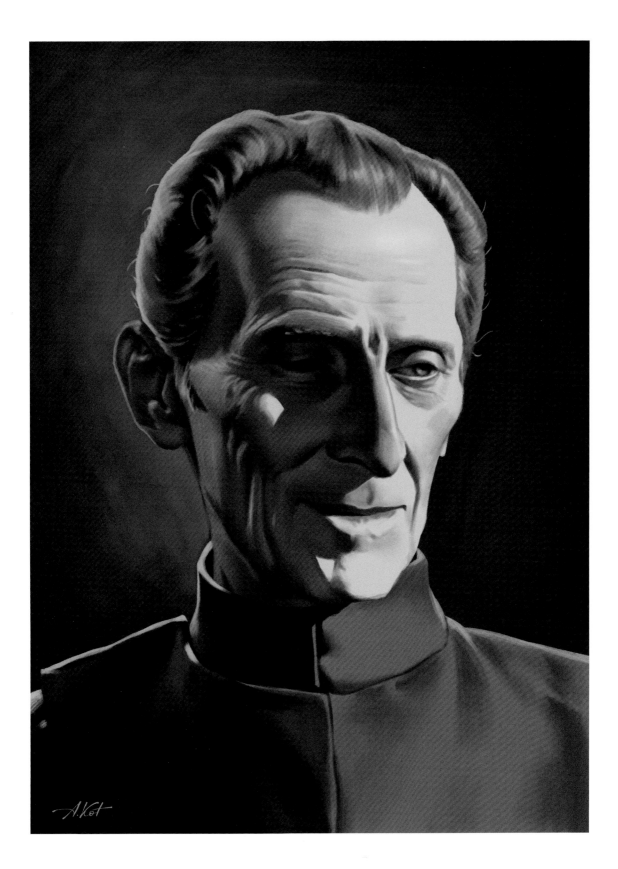

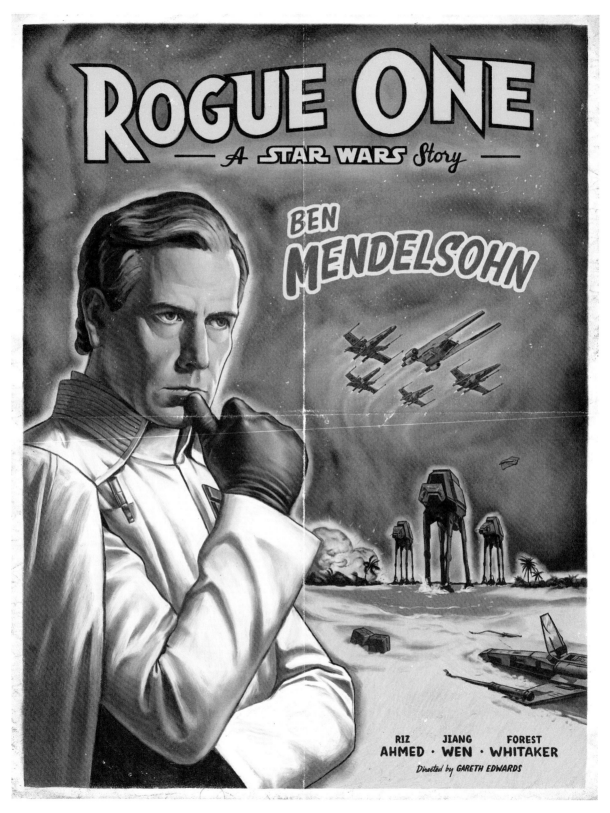

Rogue One (both pages)

# Amien Juugo

www.behance.net/Amien15
Instagram: @Amien15
Facebook: @Amien15

## "STAR WARS IS OUR HOPE"

Amien Juugo is an illustrator and designer based in Makassar, Indonesia. He studied Graphic Design and Illustration at State Polytechnic of Media Kreatif.

He creates works of art through digital tools, specially vector and brush techniques. His adroitness ranges across multiple platforms involving illustrations and design for various artefacts of pop-culture and commercial, including posters, t-shirts, character designs or editorial illustration projects.

A creative concept that is based on learnings from life experiences coming mostly from his childhood. Influenced by his parents, he explored his artistic abilities from an early age, and inspired by his love of movies, cartoons and comics.

Amien Juugo es un ilustrador y diseñador de Makassar, Indonesia. Estudió Diseño Gráfico e Ilustración en la Media Kreatif State Polytechnic.

Amien crea sus obras de arte mediante herramientas digitales, especialmente técnicas vectoriales y de pincel. Es experto en numerosas plataformas de ilustración y diseño de diversos elementos publicitarios y de la cultura pop, como carteles, camisetas, diseños de personajes o proyectos de ilustración editorial. Un concepto creativo que se basa en lo que ha aprendido durante toda su vida, sobre todo en su infancia.

Influido por sus padres, Amien empezó a explorar sus habilidades artísticas desde muy temprana edad, inspirado por su pasión por las películas, los dibujos animados y los cómics.

Hope (right page)

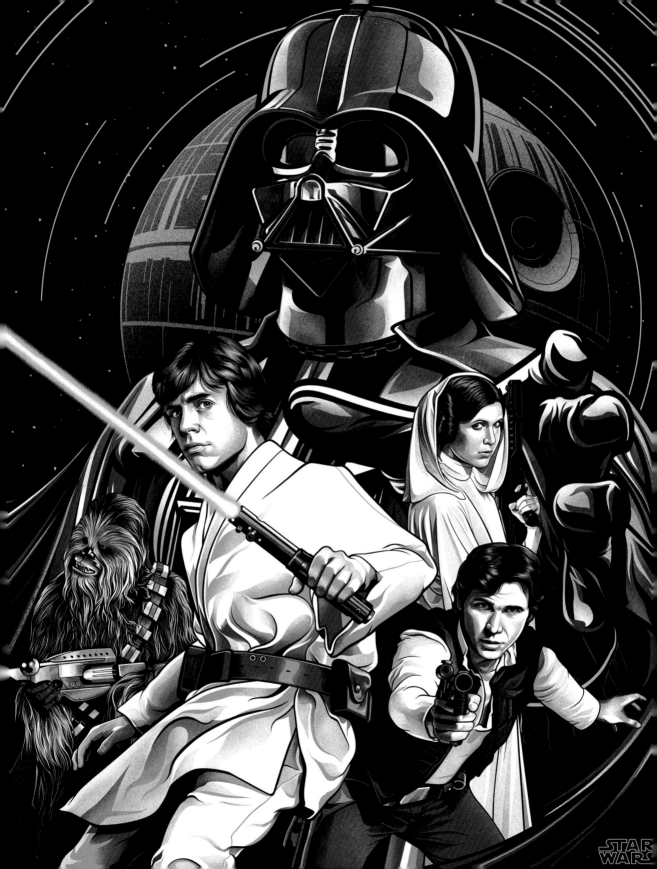

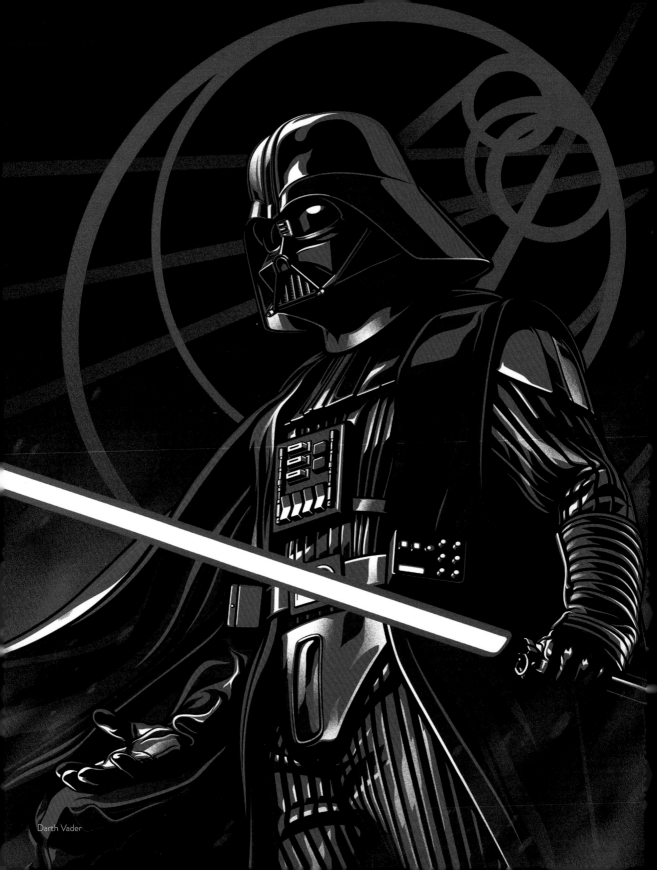

Darth Vader

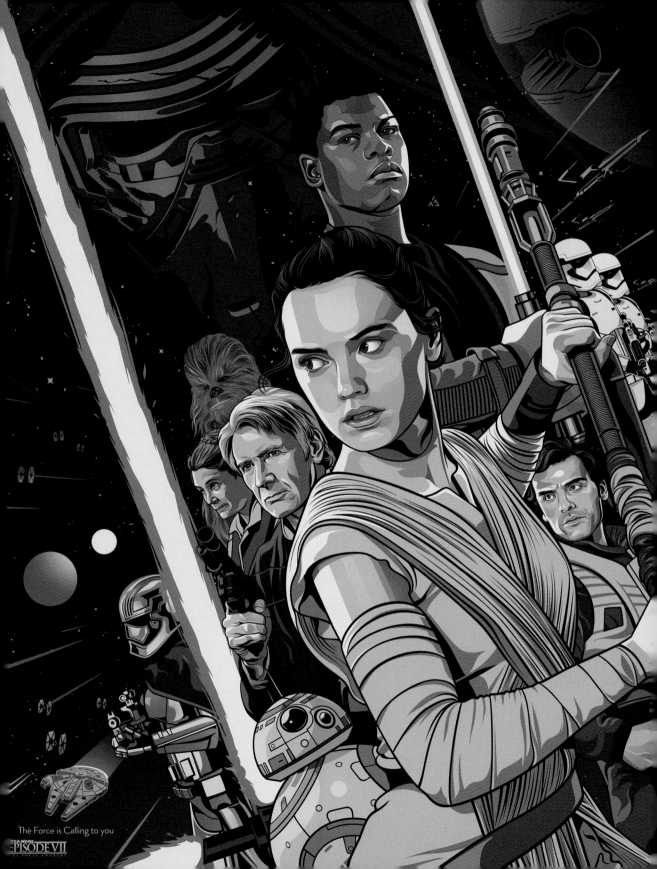

The Force is Calling to you

STAR WARS
EPISODE VII
THE FORCE AWAKENS

# Ron Domingue

www.rondomingue.com
Instagram: @rondomingue
Twitter: @rondomingue

## "STAR WARS WAS MY FIRST IMMERSIVE EXPERIENCE INTO MY IMAGINATION. YOU WANTED TO KEEP TELLING STORIES WITHIN THAT UNIVERSE GEORGE LUCAS CREATED"

Ron Domingue is an artist, designer, and illustrator. He has studied History and Fine Art with a concentration in Drawing and Printmaking at the University of Louisiana at Lafayette. He has collaborated and worked with high profile clients and brands. Currently resides in the Garden District, New Orleans, Louisiana and is addicted to HBO and basketball.

Ron Domingue es artista, diseñador e ilustrador. Estudió Historia y Bellas Artes, con especialización en Dibujo y Grabado, en la Universidad de Louisiana, en Lafayette (EE. UU). Ron, que ha colaborado con clientes y marcas de postín, reside actualmente en el Garden District de Nueva Orleans, Louisiana, y es un adicto a HBO y al baloncesto.

Star Wars 1977 (right page)

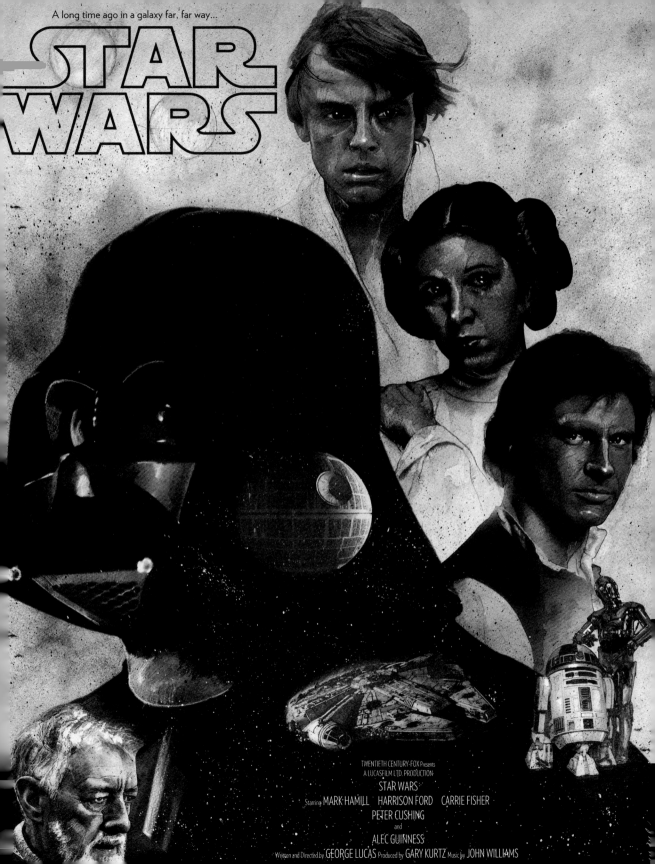

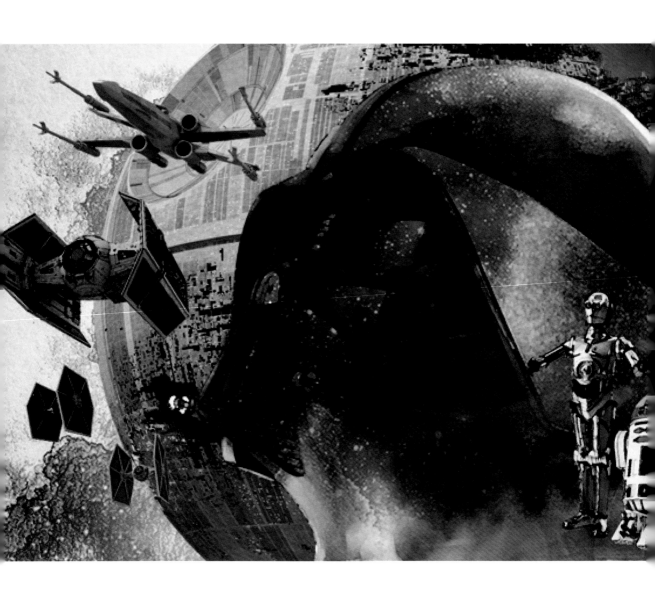

The Balance of the Force

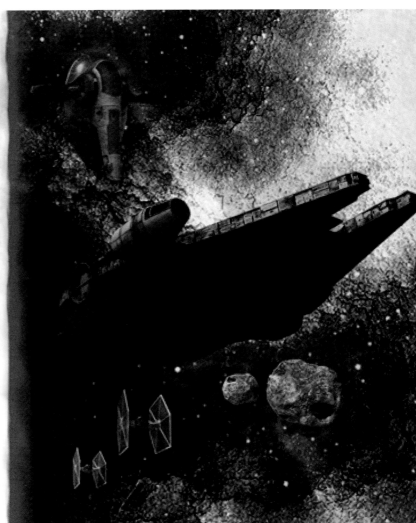

# Benedict Woodhead

www.benedictwoodhead.com
Instagram: @benedict_woodhead
Twitter: @woodheadart
Facebook: @benedictwoodhead

## "STAR WARS INSPIRES ME BECAUSE OF THE ENDLESS OPPORTUNITIES TO CREATE MEANINGFUL COMPOSITIONS WHICH APPEAL TO SO MANY PEOPLE GLOBALLY"

As a child, Benedict was brought up on Sci-Fi, particularly Star Wars, and not only loved the films but the posters and artwork that these films generated. When he was ten years old, he was lucky enough to be given a limited edition, Star Wars print signed by the illustrator Ralph McQuarrie. From the characters and narrative, to the music and special effects, Benedict loves everything that Star Wars is.

As an artist and designer Benedict Woodhead is driven to produce work which cures his consuming and obsessive passion to redesign images from popular culture. Once he has conceived and developed an idea, he works from initial sketches through to detailed illustrations using a range of mixed media. He always aims to create a brand-new composition which sums up an entire concept in one complete design.

Benedict se crió inmerso en la ciencia ficción, especialmente en *Star Wars*. Lo que le gustaba no eran solo las películas, sino además los carteles y todo el arte que generaba la saga. Cuando tenía diez años, tuvo la suerte de recibir un diseño impreso de edición limitada de *Star Wars* firmado por el ilustrador Ralph McQuarrie. Desde los personajes a la historia, pasando por la música y los efectos especiales, Benedict es un verdadero apasionado de todo lo que tenga que ver con *Star Wars*.

Benedict Woodhead es un artista y diseñador cuyas obras buscan saciar su incontenible y obsesiva pasión por rediseñar imágenes de la cultura popular. Una vez diseñada y desarrollada la idea, trabaja a partir de bocetos iniciales que le ayudan a elaborar ilustraciones detalladas gracias a una amplia gama de técnicas mixtas. Benedict siempre se pone como meta la creación de una composición totalmente nueva que resuma un concepto entero en un diseño completo.

Vader (right page)

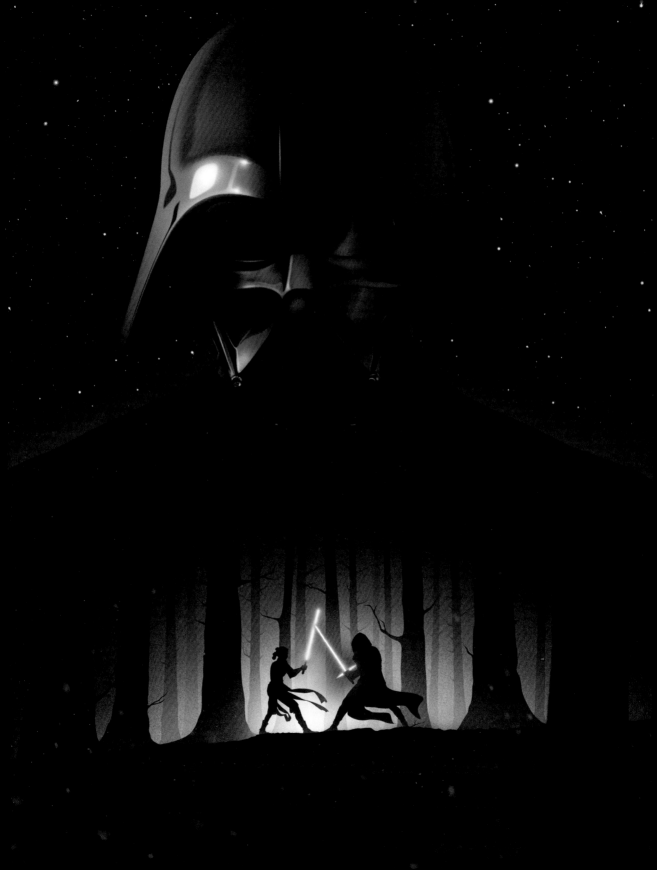

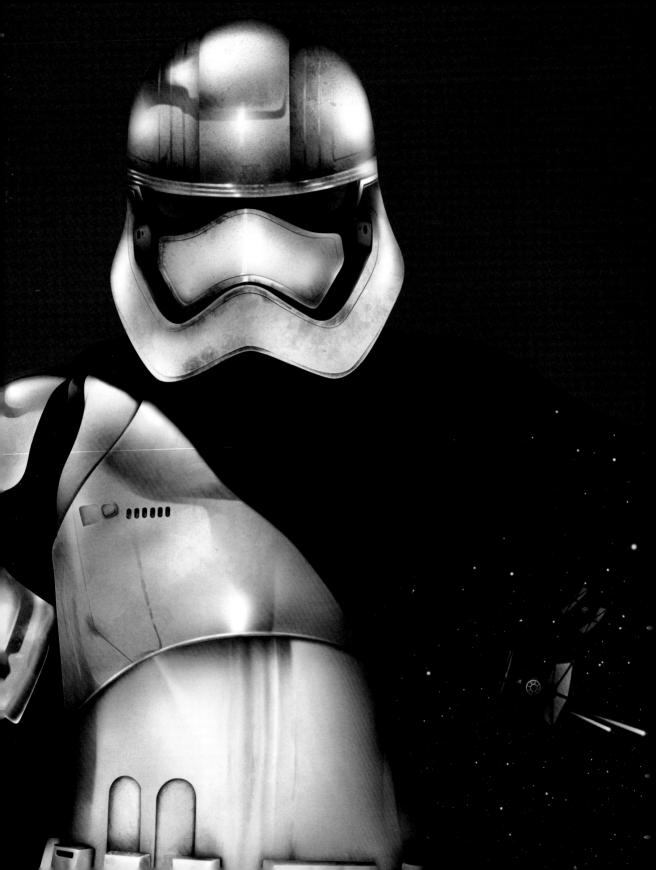

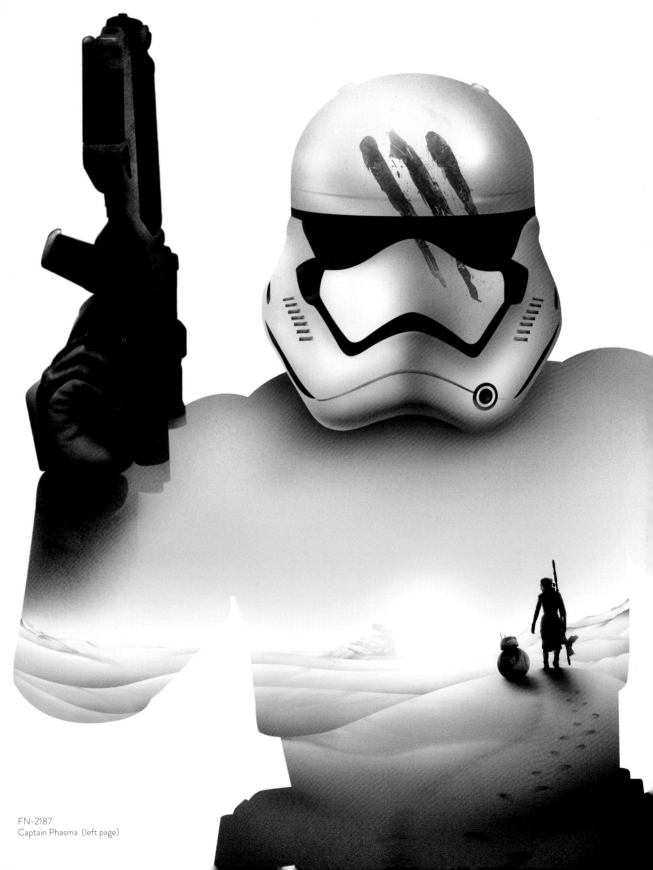

FN-2187
Captain Phasma (left page)

# Rich Davies

www.turksworks.co.uk
Instagram: @turksworks
Twitter: @turksworks
Facebook: @turksworksillustration

"WATCHING THE EMPIRE STRIKES BACK WHEN I WAS NINE YEARS OLD MADE ME REALISE THAT ANYTHING WAS POSSIBLE AND SET ME ON A PATH TO WHERE I AM NOW. IT WAS THEN I REALISED THAT THOSE AMAZING THINGS YOU SAW ON THE BIG SCREEN AND THE POSTER WERE CREATED BY AN ARTIST AND THATS WHAT I WANTED TO DO"

Based in beautiful Carmarthenshire, South Wales, Richard has worked as a graphic designer and illustrator for almost fifteen years. Inspired by the movie poster and commercial art of his youth, Richard's work is predominantly used in the entertainment and publishing industries. Over the last few years Richard has gradually built up an impressive client base, from large film studios such as Disney and Twentieth Century Fox to world renowned publishers such as Rolling Stone and Conde Nast. His commercial work has also led him to exhibit in various galleries in Los Angeles, New York, Marseille, Vienna and Zurich as well as published in various design and pop culture publications throughout the world. Richard is a member of the Association of Illustrators as well as a proud member of the international artist collective known as the Poster Posse.

Richard, procedente del bello condado de Carmarthenshire, en el sur de Gales, trabaja desde hace casi quince años como diseñador gráfico e ilustrador. Inspirado durante su juventud por el arte de la publicidad y los carteles cinematográficos, las obras de Richard suelen utilizarse en los sectores del entretenimiento y la edición. En los últimos años, Richard ha ido haciéndose poco a poco con una impresionante cartera de clientes, desde grandes estudios cinematográficos como Disney o Twentieth Century Fox hasta publicaciones de prestigio mundial como Rolling Stone o Conde Nast. Sus obras publicitarias también le han llevado a exponer en diversas galerías de Los Ángeles, Nueva York, Marsella, Viena o Zúrich, además de aparecer en varias publicaciones sobre diseño y cultura pop de todo el mundo. Richard es miembro de la Asociación de Ilustradores y del conocido colectivo de artistas internacionales Poster Posse.

The Empire Strikes Back (right page)

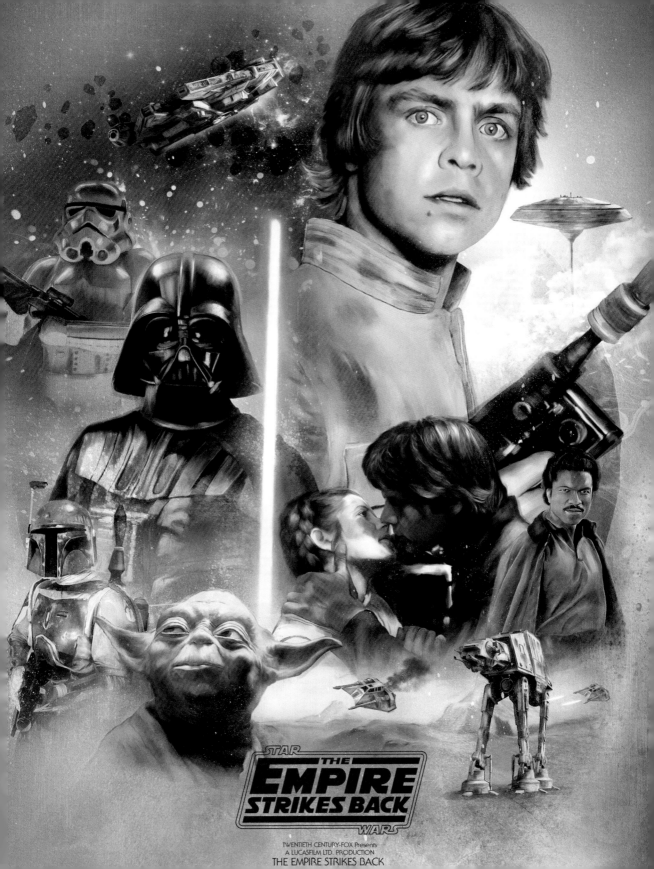

STAR THE **EMPIRE STRIKES BACK** WARS

TWENTIETH CENTURY-FOX Presents
A LUCASFILM LTD. PRODUCTION
THE EMPIRE STRIKES BACK

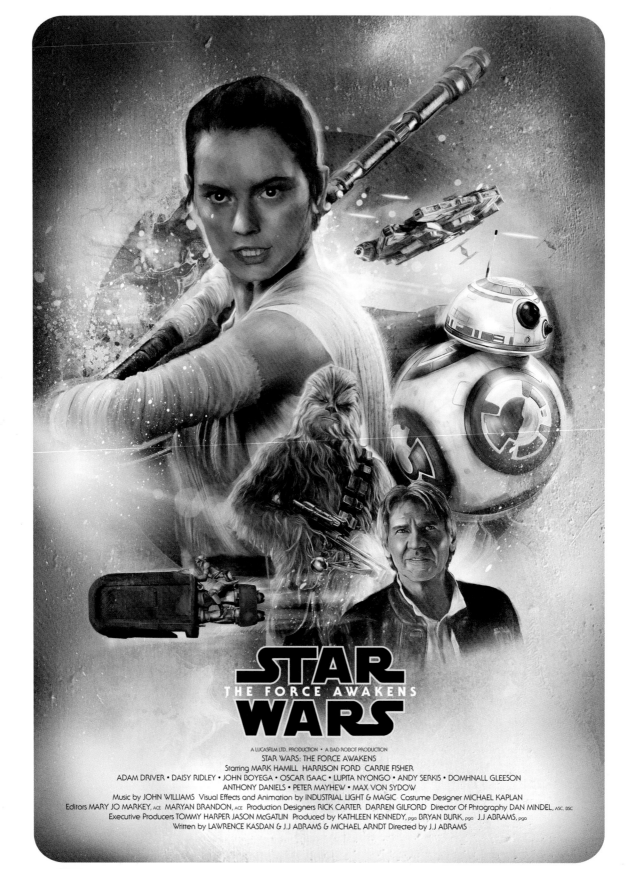

# STAR
## THE FORCE AWAKENS
# WARS

A LUCASFILM LTD. PRODUCTION  •  A BAD ROBOT PRODUCTION
STAR WARS: THE FORCE AWAKENS
Starring MARK HAMILL  HARRISON FORD  CARRIE FISHER
ADAM DRIVER • DAISY RIDLEY • JOHN BOYEGA • OSCAR ISAAC • LUPITA NYONGO • ANDY SERKIS • DOMHNALL GLEESON
ANTHONY DANIELS • PETER MAYHEW • MAX VON SYDOW
Music by JOHN WILLIAMS  Visual Effects and Animation by INDUSTRIAL LIGHT & MAGIC  Costume Designer MICHAEL KAPLAN
Editors MARY JO MARKEY, ace  MARYAN BRANDON, ace  Production Designers RICK CARTER  DARREN GILFORD  Director Of Photgraphy DAN MINDEL, asc. bsc
Executive Producers TOMMY HARPER JASON McGATLIN  Produced by KATHLEEN KENNEDY, pga  BRYAN BURK, pga  J.J ABRAMS, pga
Written by LAWRENCE KASDAN & J.J ABRAMS & MICHAEL ARNDT  Directed by J.J ABRAMS

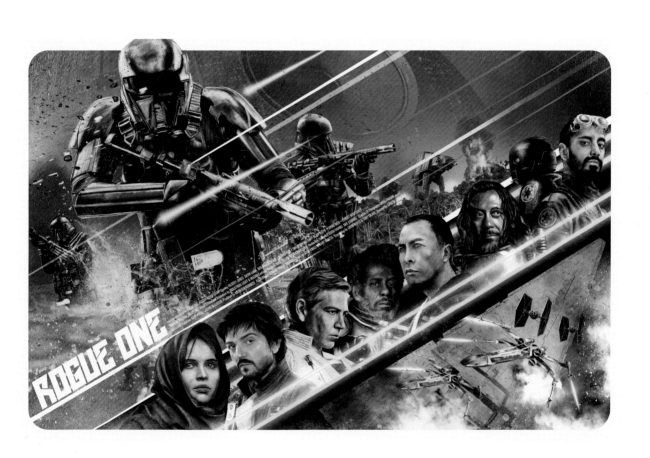

The Force Awakens  (left page)
Rogue One

# César Moreno

www.pinchemoreno.com
Instagram: @pinchemoreno
Twitter: @pinchemoreno
Facebook: @elpinchemoreno

## "STAR WARS IS LIKE A VIRTUAL BAR FULL OF FRIENDS YOU CAN VISIT ON A DAILY BASIS WHICH NEVER GETS OLD"

César Moreno is a 38 year old Mexican Art Director and Illustrator currently based on the Caribbean, he is a hardcore pop culture and beer consumer, gamer, clumsy football player and a karma believer.

His favourites topics to illustrate comes mainly from pop culture, and his graphic style is strongly influenced by comics.

His favourite tool of the trade is a cold beer next to a sketchbook.

César Moreno es un Director de Arte e ilustrador mexicano de 38 años de edad. Actualmente reside en el Caribe y consume cantidades industriales de cultura pop y cerveza, juega fútbol con más ganas que técnica y cree en la empatía.

Sus temas favoritos a ilustrar provienen de la cultura pop y en cuanto a su estilo gráfico éste tiene una fuerte influencia proveniente de las historietas.

Su herramienta favorita para ilustrar es una cerveza fría junto al cuaderno de bocetos.

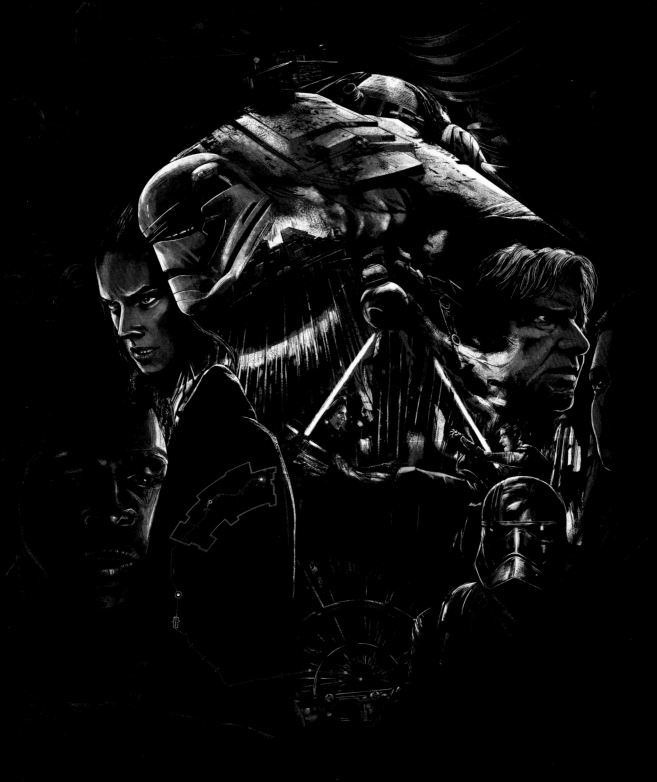

Melted Helmet

STAR
WARS
THE FORCE AWAKENS

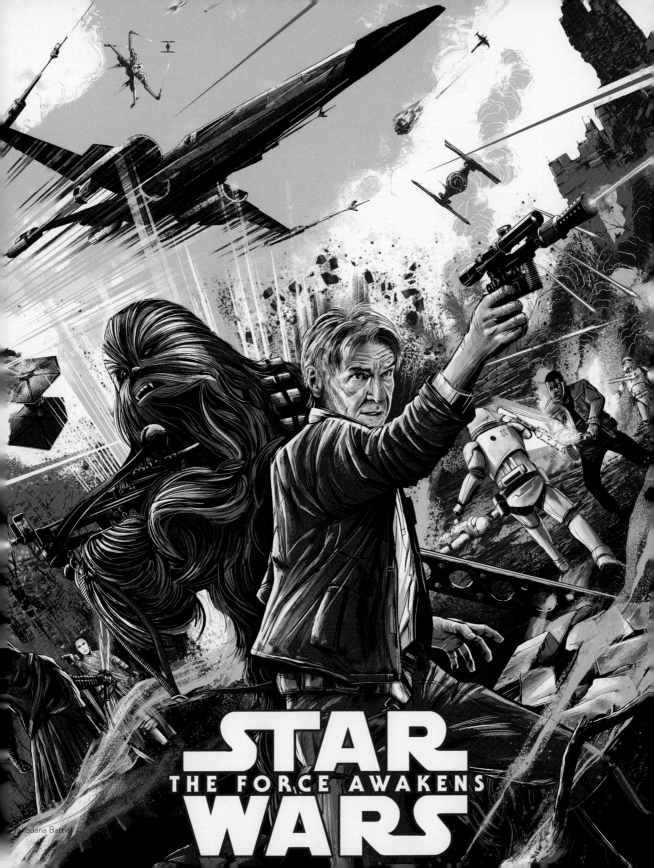

Jakkodana Battle

STAR
THE FORCE AWAKENS
WARS

# Chris Malbon

www.cmalbon.com
www.debutart.com
Instagram: @melbs74

"STAR WARS IS ABOUT ESCAPISM, A WORLD I FEEL TOTALLY AT HOME IN, FROM KNEE HIGH TO NOW I HAVE LOVED THESE STRANGE LANDS AND THE CHARACTERS THAT INHABIT THEM - I EVEN HAVE A SOFT SPOT (...A VERY SMALL SPOT - PIMPLE SIZED) FOR JAR-JAR"

Based in beautiful Bristol UK, Chris Malbon, AKA Melbs is an active member of the area's thriving art and design scene, regularly giving talks at local colleges and universities. He classes himself as a creative all-rounder, comfortable designing from the side of matchbox to large murals, be it pencil, pen, paint or pixel, he's happy using them all. Constantly figuring out innovative new concepts and ideas. His career has taken him on a journey through some renowned studios including Attik, I Love Dust, Zip and McFaul Studio. A hardworking and prolific contributor, Chris has created work for an array of clients and agencies over the past 17 years. He has worked on campaigns for Coca-Cola, Sony, London 2012, Unilever, Carhartt, Nestle, Nike and MTV and has plenty more impressive credits under his belt.

Chris Malbon, apodado Melbs y residente en la bonita ciudad británica de Bristol, es miembro activo de la pujante escena artística y de diseño de la zona, como demuestra el hecho de que imparta conferencias en institutos y universidades cercanos. Se considera a sí mismo un todoterreno creativo que se encuentra a gusto diseñando desde una caja de cerillas hasta un gran mural, ya sea con lápiz, bolígrafo, pintura o píxel, cuatro métodos que domina a la perfección. Chris no deja de buscar nuevos conceptos e ideas innovadoras. Durante su carrera, ha trabajado para estudios de renombre como Attik, I Love Dust, Zip o McFaul Studio. Trabajador incansable y prolífico, Chris ha creado arte para una amplia cartera de clientes y agencias en los últimos 17 años. Ha trabajado en campañas para Coca-Cola, Sony, Londres 2012, Unilever, Carhartt, Nestle, Nike y la MTV, y cuenta con un montón de méritos más en su haber.

Imperial Death Tropper portrait - The Force Awakens  (right page)

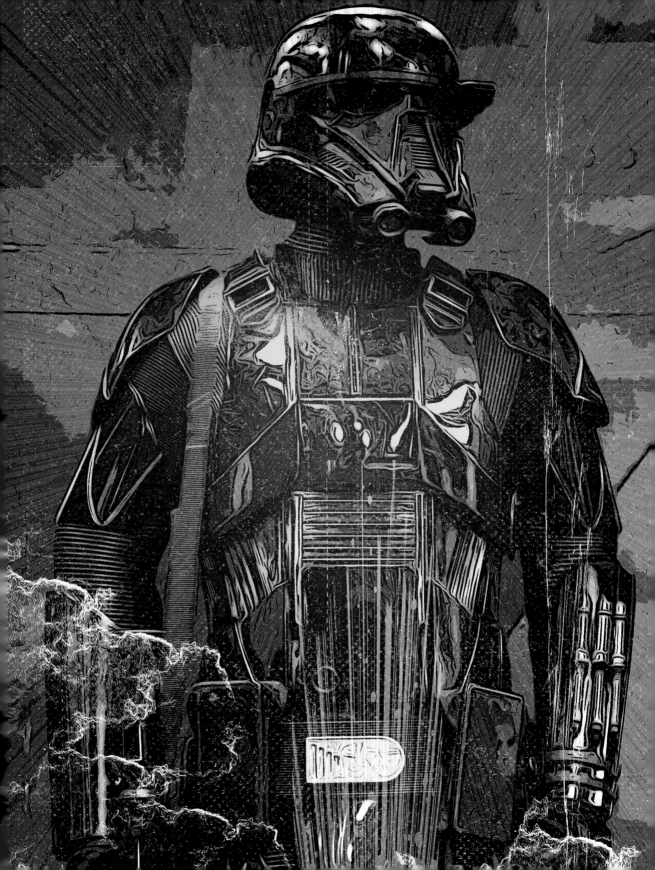

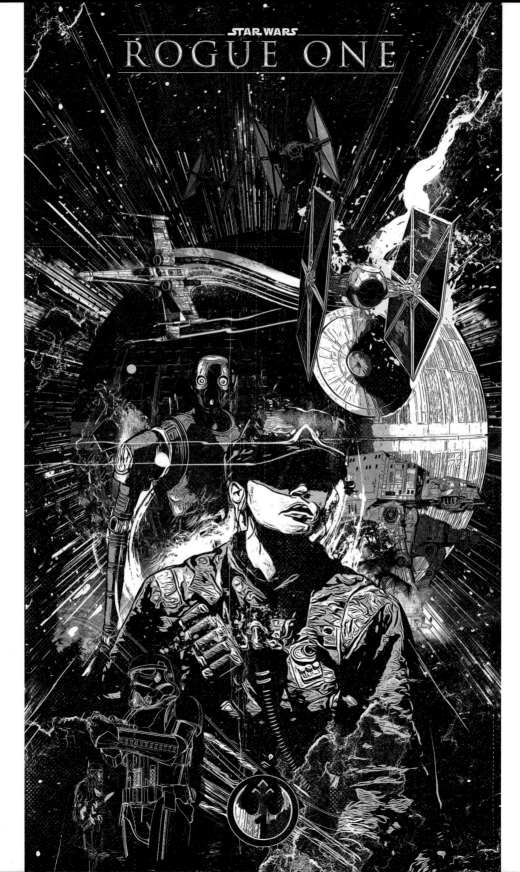

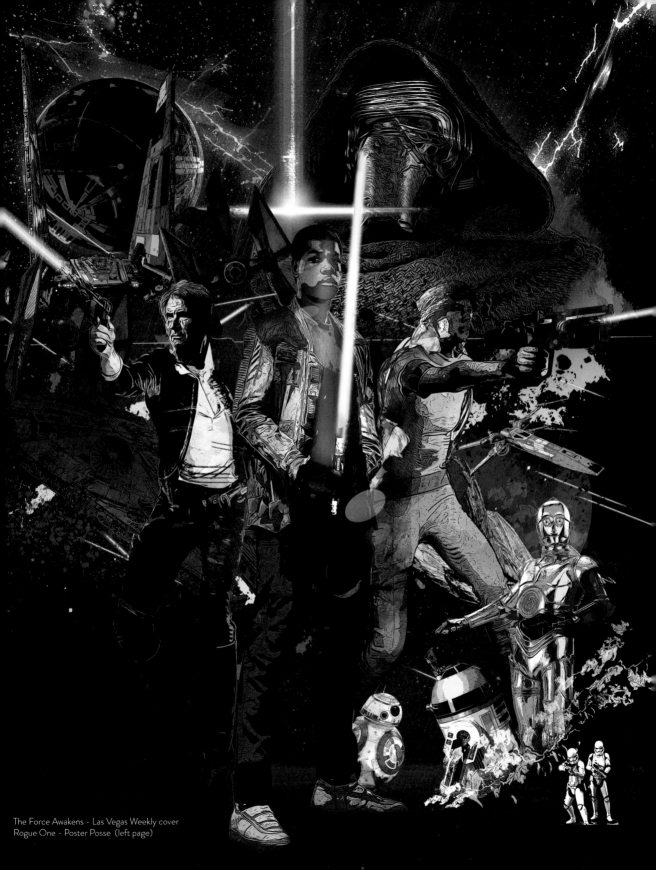

The Force Awakens - Las Vegas Weekly cover
Rogue One - Poster Posse  (left page)

# Flore Maquin

www.flore-maquin.com
www.behance.net/floremaqui9d77
www.dribbble.com/FloreMaquin
Instagram: @flore_maquin
Facebook: @floremaquin

"THE REAL «FORCE» OF THESE FILMS LIES IN THEIR ARTISTIC CREATIVITY.
STAR WARS HAS MANAGED TO BE TIMELESS AND AGING WONDERFULLY WELL, THAT'S THE DEFINITION OF ART"

Flore Maquin is a French graphic designer based in Lyon. She discovered graphic design during her tourism studies and quickly decided to change her career by moving towards advertising and then to the cinema. She is now moving towards the illustration and digital painting of her favorite cinematographic characters. She likes to bring her own vision of her favorite characters with a real inspiration from 80's pop culture.

Flore Maquin es una diseñadora gráfica francesa, de Lyon. Descubrió el diseño gráfico durante sus estudios de turismo, y enseguida decidió cambiar de aires, adentrándose en el mundo de la publicidad, y posteriormente del cine. Actualmente, Flore ha empezado a trabajar en la ilustración y la pintura digital de sus personajes cinematográficos preferidos. Lo que más le gusta es aportar su propia visión sobre sus personajes favoritos inspirándose de lleno en la cultura pop de los 80.

Rogue One (right page)

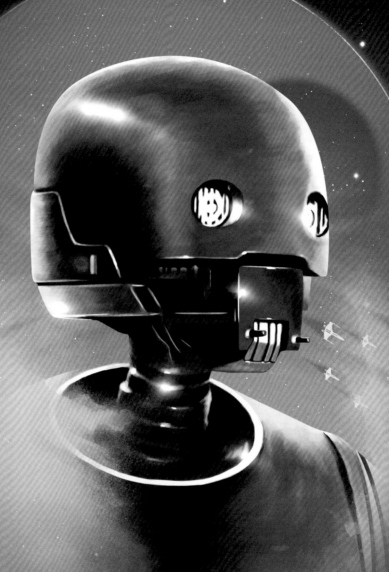

ROGUE ONE

A STAR WARS STORY

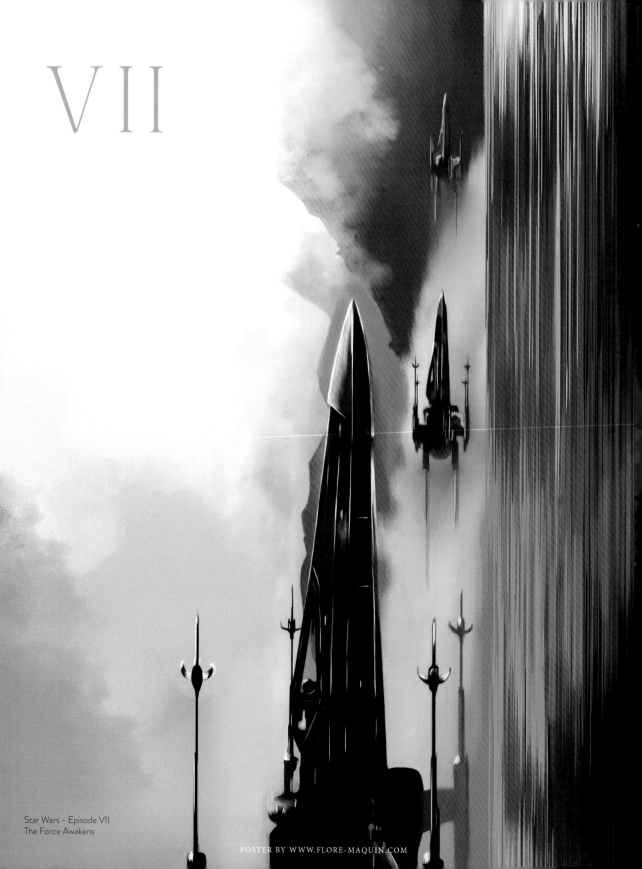

VII

Star Wars - Episode VII
The Force Awakens

POSTER BY WWW.FLORE-MAQUIN.COM

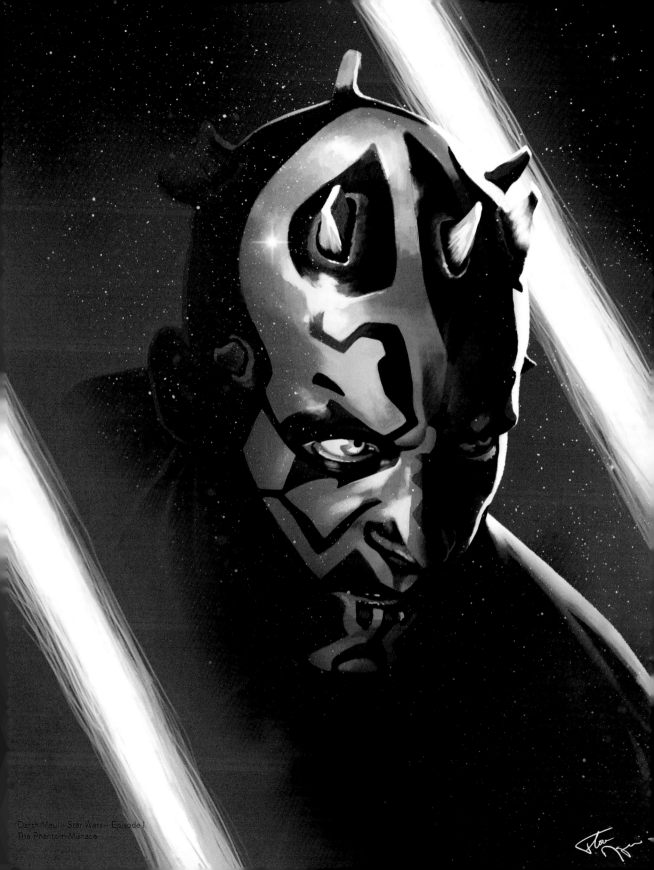

Darth Maul - Star Wars - Episode I
The Phantom Menace

# Laura Racero

www.lauraracero.com
Instagram: @lauraracero
Twitter: @lauraracero
Facebook: @laura.racero.artist

"THE MAGIC OF STAR WARS DOES NOT LIE IN ITS BRILLIANT SPECIAL EFFECTS. ITS POWER EMANATES FROM SOMETHING MUCH SIMPLER AND MORE UNIQUE: THE AIR OF ROMANTICISM THAT SURROUNDS THE STORY; THAT'S WHAT REJUVENATES US AND MAKES US BELIEVE ANYTHING IS POSSIBLE"

The first time Laura used a pencil, she was 3 years old. Since then she has not stopped drawing and experimenting with various artistic media, finding her vocation in illustration, photography and graphic/ digital design.

The first film she saw was The Empire Strikes Back, and thus began her passion for the world of cinema, fantasy and sci-fi. Huge, colourful reproductions of the posters of the films being projected were hung over the fronts of the cinemas, and Laura observed them with fascination. The poster that made her fall in love with the profession was created by Richard Amsel for Raiders of the Lost Ark. Along with him, Drew Struzan soon became a major influence. In her early fanart illustrations, Laura tried to imitate his style using digital techniques. Little by little, however, she found her own. And the day the director of the science fiction short film REM asked her to design its poster is when it became more than just a hobby.

La primera vez que Laura usó un lápiz tenía 3 años. Desde entonces no dejó de dibujar y experimentar con diversos medios artísticos, encontrando su vocación en la ilustración, la fotografía y el diseño gráfico/digital.

La primera película que vio fue Empire Strikes Back, y así comenzó su pasión por el mundo del cine, la fantasía y la sci-fi. En las fachadas de las salas se mostraban enormes y coloridas reproducciones de los carteles de las películas que proyectaban, y Laura las contemplaba fascinada. El póster que hizo que se enamorase de la profesión fue el creado por Richard Amsel para Raiders of the Lost Ark. Junto con él, Drew Struzan se convirtió enseguida en referente. En sus primeros fanart, Laura intentaba imitar su estilo utilizando técnicas digitales. Poco a poco, sin embargo, encontró el suyo propio. Y el día que el director del cortometraje de ciencia-ficción REM le pidió que diseñara su cartel, dejó de ser un hobby.

Kylo - Rogue One  (right page)

STAR WARS
THE FORCE AWAKENS

KYLO REN
BORN BEN SOLO
FORCE-SENSITIVE
MASTER of THE KNIGHTS of REN

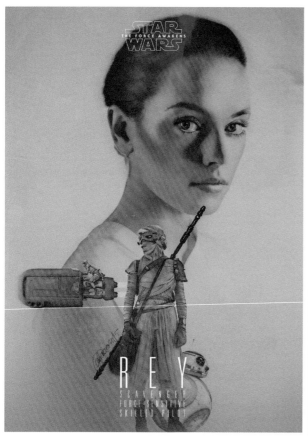

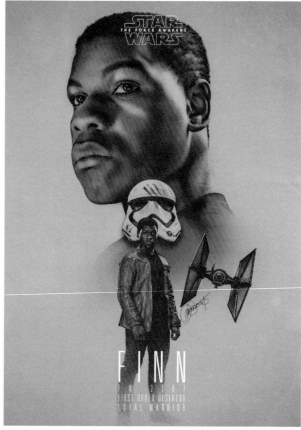

Rey - Rogue One (left)
Finn - Rogue One (right)
The Force Awakens (right page)

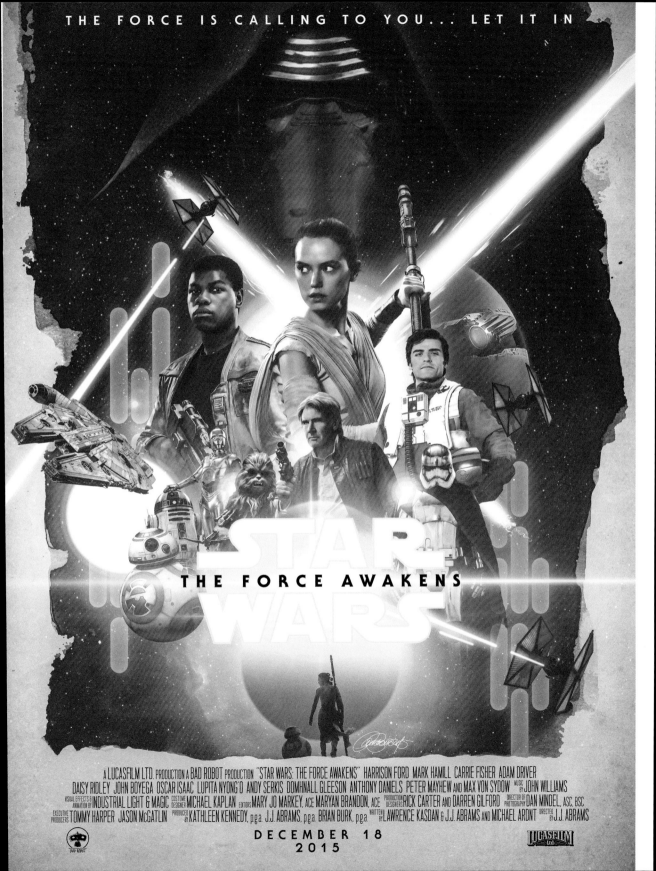

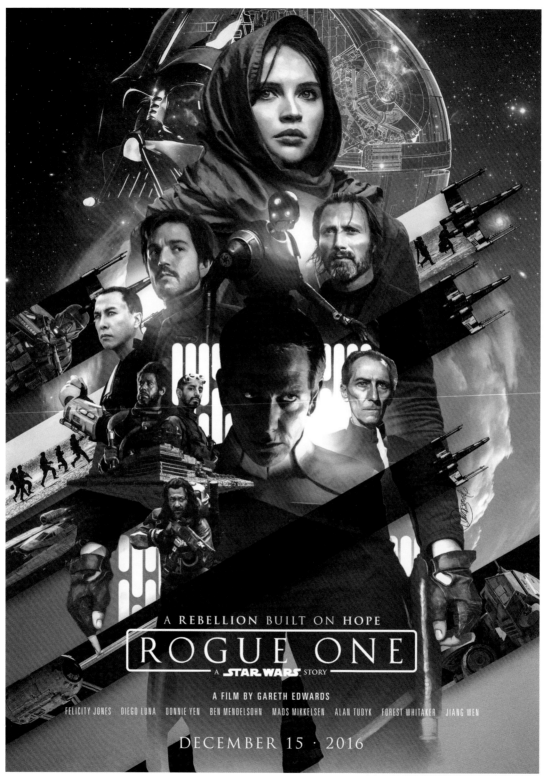

Rogue One
The Force Awakens (right page)

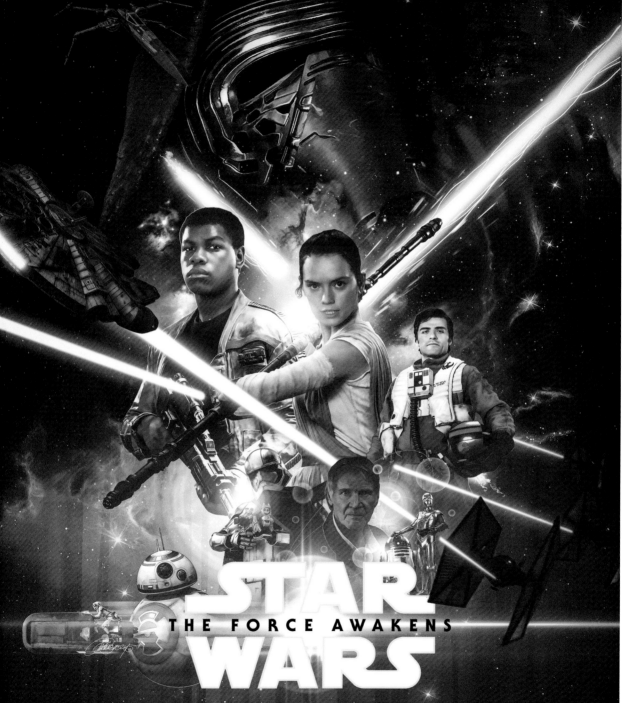

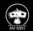

# Liza Shumskaya

www.shumskayaart.tumblr.com
Instagram: @kino_maniac
Facebook: @Liza-Shumskaya

## "STAR WARS IS A CINEMATOGRAPHIC PHENOMENON THAT UNITED WHOLE GENERATIONS"

Liza Shumskaya is an Illustrator born and currently based in Kiev, Ukraine. Most of her artworks is devoted to pop culture – films tv shows and music. Since childhood, she loved drawing, had been improving her skills and little by little a passion for cinema and art turned into a favorite full-time job. And movie posters was a perfect way to express her interest in this area. She believes that it is a unique kind of art, which can tell you a story without a single word, to convey the mood and atmosphere - whether it's a movie, a TV show or a song. Her works can be found in ARTtitude's / Poster Spy – "Alternative Movie Poster Collection" and in PRINTED in BLOOD's "The Thing: Artbook" . Also her Print for Netflix original serial "Stranger Things" have been exhibited in Menagerie gallery, Sacramento, CA at the One-Night-Only "Stranger Things" Themed Art Show.

Liza Shumskaya es una ilustradora nacida y residente en Kiev, Ucrania, que ha dedicado la mayor parte de sus obras a la cultura pop (películas, programas de televisión y música). Le encantaba dibujar desde que era niña. Luego fue mejorando poco a poco hasta que su pasión por el cine y el arte se convirtieron en su trabajo favorito a tiempo completo; y los carteles cinematográficos eran la forma perfecta de expresar su interés en este ámbito. Liza cree que trasladar la atmósfera y el estado de ánimo que transmite una película, un programa de televisión o una canción es un tipo de arte único, puesto que es capaz de contar una historia sin emplear una sola palabra. Sus obras se encuentran publicadas en "Alternative Movie Poster Collection", de ARTtitude / Poster Spy, y en versión impresa en "The Thing: Artbook", de BLOOD. Asimismo, sus obras impresas para la serie original de Netflix *Stranger Things* se han expuesto en la galería Menagerie de Sacramento, California, en un espectáculo artístico sobre la serie que tuvo lugar una sola noche.

Rebel (right page)

# REBEL

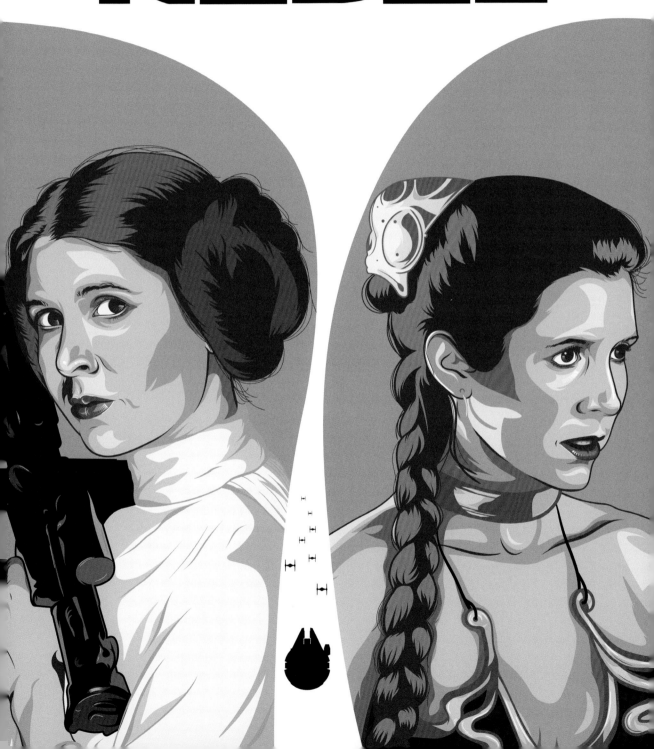

Generation (both pages)

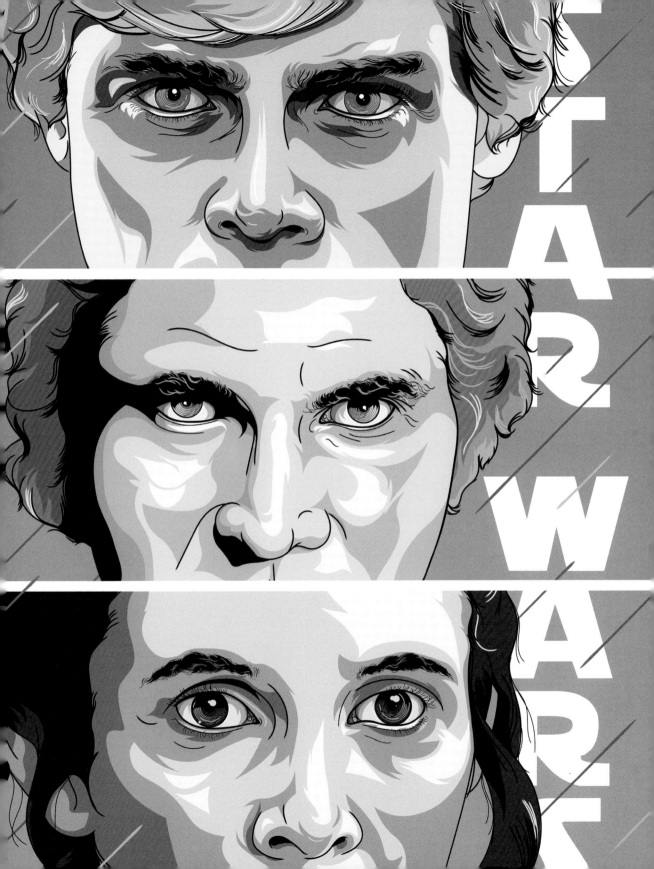

# Alain Bossuyt

www.behance.net/alainB8

"I WAS ABOUT 10 YEARS OLD WHEN I SAW THE FIRST STAR WARS MOVIE IN 1978. IT WAS A SHOCK TO ME, THESE INCREDIBLE IMAGES, THE SHIPS, THE FIGHT OF DARTH VADER AND OBI-WAN KENOBI, THE FORCE ... I AM SAID: "WE CAN DO EVERYTHING IN THE MOVIES!!" TODAY, THE STAR WARS SAGA INSPIRES ME IN MY WORK AND EVEN IN MY DAILY LIFE. HOW COULD THESE FILMS HAVE BEEN WORSHIPED BY SO MANY PEOPLE? IT REMAINS A MYSTERY BUT IT'S VERY GOOD!"

Born in Lille, France, Alain Bossuyt is a graphic designer and illustrator. Fan of cinema and comics, he realizes reinterpretations of posters of films, or "fan-arts" since 2011.

Nacido en Lille, Francia, Alain Bossuyt es diseñador gráfico e ilustrador. Fan del cine y los cómics, realiza re-interpretaciones de carteles de películas o "fan-arts" desde 2011.

Star Wars: Episode IV - A New Hope (right page)

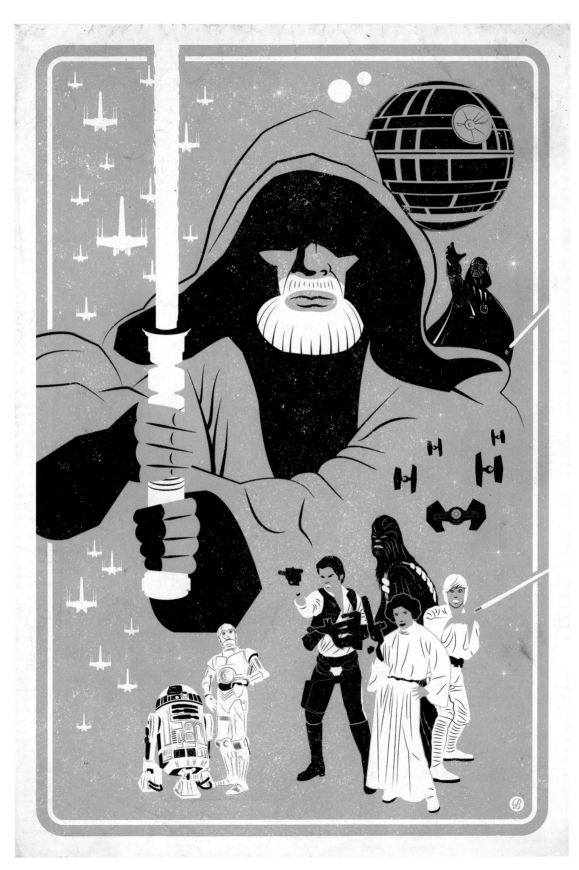

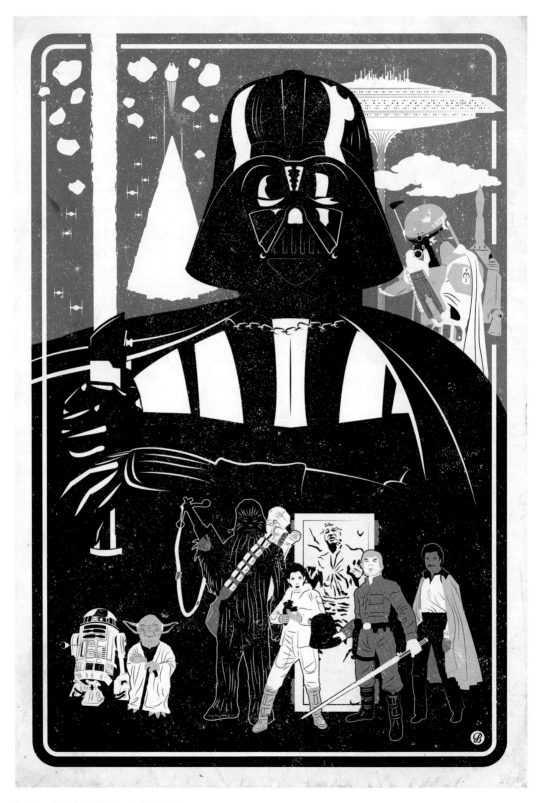

Star Wars: Episode V - The Empire Strikes Back

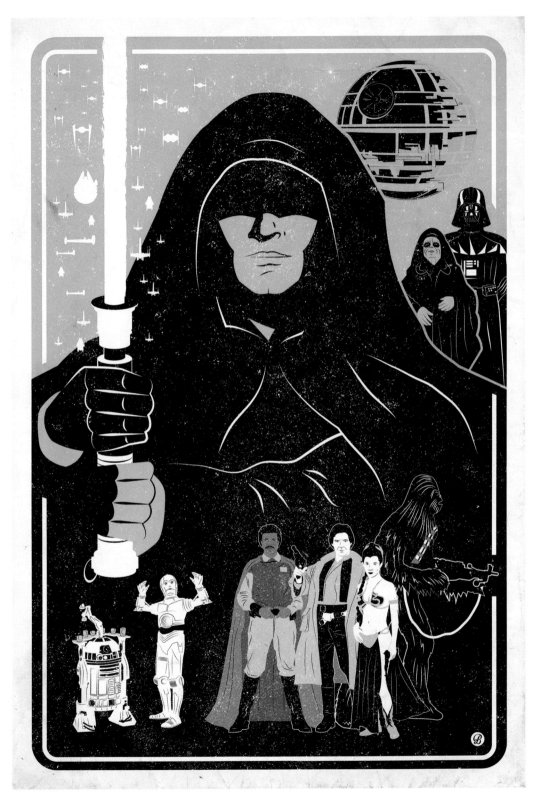

Star Wars: Episode VI - Return of the Jedi